THE ARTFUL ROUX

MARINE PAINTERS OF MARSEILLE

INCLUDING

A Catalogue of the Roux Family Paintings

AT THE

Peabody Museum of Salem

By PHILIP CHADWICK FOSTER SMITH

Curator of Maritime History

PEABODY MUSEUM OF SALEM

Salem, Massachusetts · 1978

57

COMPOSITION BY THE ANTHOENSEN PRESS, PORTLAND, MAINE

PRINTED BY THE MERIDEN GRAVURE COMPANY, MERIDEN, CONNECTICUT

CONTENTS

INTRODUCTION

THE late Jean Meissonnier, a noted collector, author, and authority on the Roux family of marine painters, once estimated the total output of its four principal practitioners—Antoine, Antoine, Jr., Frédéric, and François—at six or seven thousand pictures. If an educated guess of this sort can be made, why can we not carry it one step further? If we assume, based on surviving evidence, that each of the four became more or less proficient in his art by the time he was in his late teens and worked regularly from then until his death, the combined number of working years amounts to about 200. If, together, they painted 7,000 watercolors, each would therefore have completed not quite nine paintings a year. This seems an unreasonably low number despite the fact that much of their time was consumed by their hydrographic businesses. Antoine, the father, for instance, attempted occasionally to number his watercolors on a yearly basis. One painted in 1803 bears the figure "64."

It must be obvious that any attempt to establish a count is basically meaningless. It does demonstrate, however, that no matter how the figures are manipulated the Roux family was prolific beyond imagination.

What, then, has happened to all their paintings? If we address ourselves to the question of formal ship pictures alone, ignoring sketchbook work, the largest single collection of Roux paintings is to be found at the Musée de la Marine in Paris. By latest count, the collection consists of 145 pieces. The second largest institutional collection in the world is at the Peabody Museum of Salem, yet the Musée de la Marine and the Peabody together own less than three percent of the estimated total, a total which may well be too low in any case. Certainly attrition has taken place through neglect, fire, war, and other misfortunes. Six or eight Roux pictures were lost in the great Salem Fire of 1914 alone.

Numerous museums around the world—from the Mediterranean to the Baltic and from the Atlantic to the far reaches of the Pacific own one or more Roux watercolors, but it seems evident that the vast majority of those in existence are still in private

hands. There have been some notable personal collections: the names of Chambon, Fabre, Valette, Wheatland, Keller, and Meissonnier come readily to mind.

The first Roux painting to come to the Peabody Museum was a watercolor by François of the Salem snow *Olinda,* donated in 1894 by Elizabeth Wheatland, a daughter of the captain.

The museum was already ninety-five years old at the time, but this gift was only the two-hundredth item catalogued in the recently established department of maritime history. Until a few years before, the Peabody's collecting habits still reflected the tastes of its parent institution, the Salem East India Marine Society, which had been founded in 1799 by a group of educated, adventurous Salem ship masters and supercargoes who had navigated the waters in or around Cape Horn and the Cape of Good Hope, the qualification for membership.

These young men had amassed a collection of "natural and artificial curiosities" from all parts of the globe, curiosities which would be better described in modern terms as specimens of natural history and ethnological artifacts particularly related to non-European peoples.

Although an occasional ship portrait or ship model found its way into the museum of the East India Marine Society at a relatively early stage, it was the exception rather than the rule and was accepted usually because it illustrated some important event or innovation. Not until the last quarter of the nineteenth century, when Salem was fast fading as a port of any consequence, did the museum attempt to assemble maritime artifacts and pictures pertaining to its more glorious days. Until then, there had been no reason for doing so. Ships' hardware had been so commonplace no one thought to preserve examples of it for future generations to see. Nautical instruments were utilitarian objects and, once past use, fit for nothing more than sentimental keepsakes. Old sea chests were most convenient in bedroom alcoves to store reserve linen and blankets. Ship pictures were never considered to be anything more than attractive adjuncts to a

counting room, an office, a back hall of a house, or, perhaps in some cases, as part of the furnishings of a sitting room or library.

As the seafaring population of Salem began to dwindle, several farseeing senior staff members of the Peabody Museum, John Robinson in particular, exercised their knowledge of Salem people and their consequent entrées into Salem homes, to seek out and acquire for the museum the mementos of a fast-disappearing way of life.

This is not to say that Roux ship portraits were received by the museum on a daily, or even yearly basis, but from time to time one was added, and interest in them was always strong. In those days, the museum was acquiring, largely by gift, pictures of local vessels painted by a diverse gallery of late eighteenth- and nineteenth-century artists, many of whom flourished in the Mediterranean basin: Raffael Corsini at Smyrna, Honoré Pellegrin and Nicolas Cammillieri at Marseille, Giuseppi Fedi at Leghorn, Domenico Gavarrone at Genoa, Giovanni Luzro of Venice, and Felice Polli at Trieste, among others. Little by little, however, the museum picture collection became more catholic in nature and ceased to restrict itself primarily to locally owned vessels. Today, its original maritime painting and drawing collection, excluding logbook sketches and mechanically reproduced prints, numbers approximately 2,500 items. These represent the work of some 550 identified (and a host of unidentified) marine artists and illustrate vessels from many different countries.

Despite the diversity of the ship portraits being assembled three-quarters of a century ago, interest in the Roux family of Marseille continued to grow. By 1920, the museum owned fifteen Roux paintings, not necessarily because it sought them out as such but because they came in as part of the normal collecting pattern. Within another few years, they would be considered among the elite of the genre. Then, in 1922, a group of men interested in ships and the sea came together in Salem to form an independent publishing enterprise known as the Marine Research Society. It was never officially part of either the Peabody Museum or of its sister institution in Salem, the Essex Institute, but the society's headquarters tended to shift from one place to the other because the founders were intimately con-nected with both. Among these were Lawrence Waters Jenkins, then assistant director in charge of the Peabody Museum; John Robinson, keeper of the Peabody's "Marine Room" and one of the institution's trustees; Thomas Perkins, a bookseller; and the society's guiding light, George Francis Dow, formerly secretary of the Essex Institute but by then director of the museum of the Society for the Preservation of New England Antiquities.

The Marine Research Society's first volume, *The Sailing Ships of New England,* edited jointly by Messrs. Robinson and Dow, made its appearance that same year. It was one of the first "picture books" ever produced to deal extensively with the genre of ship portraiture, and numerous Roux works were represented in it. While more of the society's volumes—volumes on piracy, voyaging in the South Seas, rigging practice, and others—rolled off the presses during the next several years, George Francis Dow initiated a voluminous correspondence to assemble sufficient information about the Roux family, as well as photographic representations of its paintings, to permit publication of a book devoted exclusively to the family's works.

His most promising source was, of course, Marseille, and his "whip" there turned out to be Alphonse Cyprien Fabre, an attorney-at-law who himself was an avid devotee and collector of Roux watercolors. Through Fabre's enthusiastic efforts, many Roux descendants and other owners of the family's artistic endeavors were persuaded to open their doors to the photographers. Soon, a flood of photographic prints began reaching Salem.

One, among many of Fabre's major contributions to the successful publication of *Ships and Shipping* in 1925, was the information sent to Dow and his associates that in 1883 a rare little monograph by one Louis Brès had been published at Marseille under the title *Une Dynastie de Peintres de Marine, Antoine Roux et ses Fils.* Excitedly, Dow asked him to obtain a copy in order that a translation of it could be incorporated into the book, but not one could be found. "La brochure de BRES," Fabre was to reply, "que votre Société se propose de tra-duire est devenue introuvable en librairie [book shops]."

At length, through the good offices of Wesley Frost, American Consul at Marseille, a copy was

acquired. "The search for the pamphlet was longer and more tortuous than I would have believed," he reported, "especially as the book dealers and librarians here are alike indisposed to undue exertion. I was finally fortunate enough to make the acquaintance of the 'Archivist' of the Marseille Chamber of Commerce, M. Joseph Fournier, a gentleman of fine personality and of the highest distinction in his field. M. Fournier had a copy of the ANTOINE ROUX in his private library; and I shrewdly suspect it is the copy which I am enclosing herewith. At all events M. Fournier kindly let me know, after the lapse of some days, that I might apply to a certain book-store; and on applying . . . I was handed the pamphlet at a price too modest to mention."

Interest generates interest, so it comes as no surprise to learn that *Ships and Shipping*, not only during the formative research and production days but also following publication, generated even more interest in Roux paintings than had existed hitherto.

Among those who had fallen in love with these colorful, crisply delineated representations of bygone vessels was Richard Wheatland (1872-1944), secretary of the Peabody Museum of Salem. First encouraged by John Robinson, his father-in-law, to collect the work of Murdoch McPherson, a Canadian-born copyist who made innumerable copies of privately owned ship portraits in and around Salem, he had begun to keep a weather eye out for Roux originals. With the assistance of Dow, Wheatland set about to acquire additional pieces for the museum collection and for his own. Throughout the next decade, and more, he purchased Roux paintings wherever they could be found. Most came from France, as might be expected. He was singularly successful in his endeavors, and at its height the Richard Wheatland Collection numbered forty examples or more. During his lifetime, many of the Roux watercolors accessioned by the Peabody Museum as "purchases" were, in fact, obtained by means of his generosity. With few exceptions, the portraits of American ships he discovered found their way to the museum, whereas the foreign-flag vessels he retained for himself and his children. They, in their turn, have been unremittingly generous to the museum.

Not the least of these accessions was a remark-able series of nineteen sketchbooks by Antoine Roux, the father, acquired in two lots in 1928. Painted between the years 1790 and 1826, they graphically illustrate the elder Antoine's work during his most productive years. How the first seventeen of these were unearthed is a story in itself. The details of it come from two sources, the museum's formal records and a newspaper cutting retained in its Roux photographic file. One adds information not covered by the other, yet where they overlap they are substantially in agreement. So, the verisimilitude of the journalistic account, even though written in a highly facetious style, does not seem to be in serious question.

Originally written for the *Boston Globe* but sent special to the *Brooklyn Eagle* and printed by that well-known newspaper on April 14, 1928, A. J. Philpott spoke of a Mrs. Kelly who happened one day upon the Peabody Museum.

"The woman in the case was Mrs. Kelly," he stated. "The man in the case was Lawrence W. Jenkins, director of the Peabody Museum. He is also curator of ethnology. Mr. Jenkins can swear that he never saw or heard of Mrs. Kelly until one day about six months ago when she strolled into the Peabody Museum on Essex St. Mrs. Kelly can swear that she never saw or heard of Mr. Jenkins until that beautiful afternoon when she happened in at the Peabody Museum—by accident."

It seems that Mrs. Kelly was merely a sightseer who wished to see the sights of Salem. She had never heard of the museum. "So," the story continued, "she just happened to stumble into the Peabody Museum, and there she got the thrill that has stamped Salem on her memory for life. That includes Mr. Jenkins."

For some hours, Mrs. Kelly poked about the museum, being astounded by what she saw. "But as yet she hadn't seen Mr. Jenkins. She saw a great many curiosities before she met him . . . At first she was rather bewildered, for here she found large models of ancient sailing vessels and pictures of all kinds of sailing vessels on the walls—vessels that sailed out of Salem more than 100 years ago; that sailed to ports in the far corners of the world—in Africa, India, China, the Malay Archipelago, the Philippines, South America and the South Sea Islands."

Among the remarkable things she saw—"galleries

containing more wonderful things, a richer and more varied assortment of things antique than even King Tut's tomb in Egypt could boast . . . She was thrilled"—among the remarkable things she "noticed particularly a group [of pictures] by Antoine Roux of Marseilles. . . ." Bells began to ring.

"Mrs. Kelly," the account went on, "evidently knew something of Antoine Roux, for the pictures by him which she saw on the wall stirred in her memories that decided her to hunt up the director of the museum, Mr. Jenkins. When she found him in his office she asked whether he was interested in Antoine Roux. Mr. Jenkins was very much interested in Antoine Roux. In fact, Antoine Roux had been a hobby with him for years. Asked whether he would be interested in some sketch books by Antoine Roux, Mr. Jenkins thought he would be. Where were they?"

His glazed expression almost can be imagined, but at last the truth came out. She told him that during a recent visit to Paris she had run across a number of "sketch books by Antoine Roux in a little antique shop kept by an American woman, Gertrude Hamilton, at 15 [50] Rue de Colisée. Mrs. Kelly thought the sketch books were still in that little shop. . . It didn't seem possible to Mr. Jenkins that any such treasure could be lying around loose in a little shop in Paris. . . . However, Mr. Jenkins thanked Mrs. Kelly for her 'tip' and wrote at once to Miss Hamilton in Paris."

Gertrude Hamilton's reply to Lawrence Jenkins, from the museum's formal records, dated October 11, 1927, confirmed their existence and availability. "They belonged to a widow," she informed him, "a French woman who told us that they had belonged to her husband. Her husband had spent a great deal of time in Marseilles, but she did not know where he found them. . . . He died in 1900 when he was about 50 years old and she had never thought of them until she saw our shop with all our ship models. She came in and asked me if I would be interested in buying some original sketchbooks of ships, she thought the name of the artist was Roux but she was not certain. I asked her to let me come that evening to see them. When I saw them, I paid her the money and carried them away with me. . . . She is a very wealthy woman but not interested in ships so she thought she would sell them."

The museum asked to examine them, on approval. In a few weeks they arrived by steamer.

"And when Mr. Jenkins showed the members of the Peabody Museum Corporation his find," A. J. Philpott wrote for his newspaper article, "that body instructed him to purchase the sketch book[s] from Miss Hamilton at once. And now these sketch books are part of the maritime treasures of the museum—open to all students and fans of Antoine Roux. To those who are interested in such things these books are a treasure. Others won't be able to see much in them."

Another two sketchbooks by Antoine were acquired from Gertrude Hamilton a few months later. She had bought them during a trip to the south of France, but in this case the source from which they had come had been "very loath to part with them." The asking price for the two nearly equaled that for the total seventeen purchased not so long before.

Although it was Joseph Roux who was nominally the patriarch of this artistic family, it was really Antoine père, his son, who first fulfilled the tradition continued by the others.

In recent times, A. Fribourg of Paris, carrying on the investigative tradition of the late Jean Meissonnier, has compiled the Roux family genealogy, a copy of which is included in this catalogue. The present author owes much to him for his sharing unselfishly the facts he has uncovered to date. The results show many Roux sailors and shipmasters in Antoine's and his children's generations, a circumstance which helps to explain how and why he came to know so much about the technicalities of rigging and sailing evolutions. The same information may also account for several known paintings, signed "F. Roux," which could not possibly have been executed by either Frédéric or François, because the dates are entirely too early for either of Antoine's sons to have been painting. There were, it appears, several persons of the name François Roux in preceding generations. Very possibly, one or both of them also wielded the brush.

Antoine Roux, Senior, is said to have trained himself by copying the work of his idol, Joseph Vernet. This may well have been the case. Whatever his inspiration, nevertheless, he set the tone for his sons' work and was influential in their early development. So far as is known, he never strayed from the west-

ern Mediterranean, and most of his recognized paintings were executed there even though there exist, such as his view of Montevideo, described and illustrated here, watercolors apparently done from the notes and descriptions of others. The Peabody Museum's photographic archives include, as another example of this sort, a portrait of the American snow *Eliza and Mary* entering the port of Salem, complete in the background with the twin lights of Baker's Island in Salem Sound, a sight Antoine never saw. Perhaps other anomalies are to be found elsewhere.

Antoine Roux, Jr., never left Marseille. Frédéric did, and after studying with the Vernets in Paris removed permanently to Havre. François was something of a hybrid, spending most of his days at Marseille but not forsaking the capital either.

A word or two must be said about the artistry of the Roux paintings. Their artistic qualities unquestionably depend upon one's point of view. The fine arts historian perhaps will see little merit in them as works of art. The maritime historian will wax lyrical about them for the correctness of their detail. The connoisseur of ship portraiture will treasure them for what they are—bold, colorful, throbbing images of ships, transmitted by paper, pigments, and genius to successive generations.

Many Roux watercolors have been exhibited in various places at various times, but only on three occasions have a great number of them been displayed in special, retrospective exhibitions.* The first of this kind, consisting of eighty-seven privately and institutionally owned watercolors, was mounted at the Penobscot Marine Museum, Searsport, Maine, during the summer of 1939. Then, in 1955, the Musée Cantini at Marseille brought together another eighty Roux pieces, including sketchbooks. The published catalogues of both were, essentially, just listings with only a minimal number of illustrations.

* Several watercolors by François were exhibited at Marseille in 1879 and others during 1883 in the "Salle des Depêches" of the newspaper *Le Petit Marseillais*. Then, in 1930, forty examples of Antoine père's works were exhibited at the Salle Manuel, Paris. This was followed in 1935 by a much smaller offering in an exhibition held at the Musée de l'Orangerie (Tuileries), Paris.

Now, the third time, it is the Peabody Museum's turn, and this book has been prepared to accompany the museum's 1978-1979 special Roux exhibition and also to serve a useful purpose even after termination of the exhibition itself.

Finally the criteria for it must be set forth. The paintings of Louis Roux of Marseille, as represented in the museum collection, have not been included because no evidence has come to light to support a kinship with the others. The name Roux, in Marseille, it must be understood, was akin to Smith elsewhere.

Certain pictures, previously believed to have been Roux work, have been omitted either as misattributions or as forgeries. Some others have been reattributed on grounds spelled out in the individual catalogue entries. Titles of pictures have been quoted exactly, notwithstanding the artists' errors in spelling or unconventional usage of accents. The translations of the Brès and Gaubert reminiscences have been quoted as provided by Alfred Johnson in the Marine Research Society's 1925 volume, *Ships and Shipping*, despite some obvious syntactical difficulties.

Each of the six presently identified Roux painters is treated separately with individual, introductory remarks. The arrangement within each section is chronological by date of the work to illustrate the styles and maturation of each artist, subdivided into categories of formal pictures, sketches, and, in one case, prints. The total represents all Roux pictures received by the Peabody Museum of Salem from its founding in 1799 through the end of the year 1977.

Publication of this catalogue has been made possible in large measure by private grants given in memory of the late Richard Wheatland.

PHILIP CHADWICK FOSTER SMITH
Curator of Maritime History
Managing Editor, The American Neptune
Editor of Museum Publications

Salem, Massachusetts
January 15, 1978

THE ROUX FAMILY OF MARSEILLE

(From the research of A. Fribourg, Paris, March, 1978)

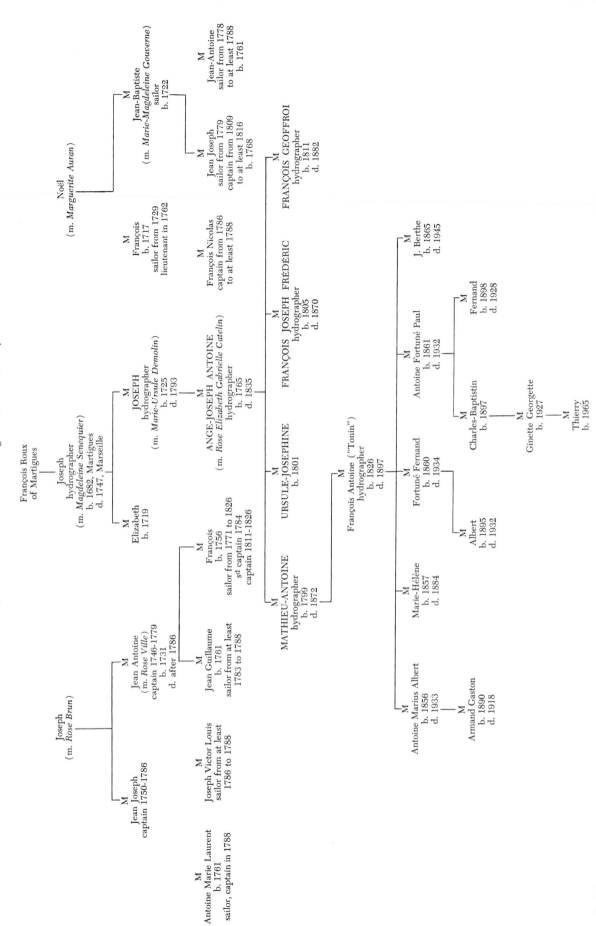

M = Marseille birth

JOSEPH ROUX (1725-1793)

AT the end of the seventeenth century, a young Frenchman moved from his native Martigues on the Etang de Berre to Marseille, some twenty-five miles to the eastward, there to learn the trade of a hydrographer. We know very little about him otherwise, except that he was born in 1682, married in 1708, and died in 1747, four years before his son and namesake, Joseph Roux, married Marie-Ursule Demolin.

Joseph, the son, like his father before him, also entered the hydrographic business, in the course of which he published, manufactured, and sold a wide assortment of charts, navigating instruments, and related nautical gear from a shop which in the English-speaking world would have been called a "navigation warehouse" but in France was disguised by the all-encompassing term "hydrographe."

A trade label, originally pasted in the wooden box of a mahogany-frame octant, presumably of his manufacture and now in the Peabody Museum instrument collection, suggests the extent of the over-the-counter paraphernalia he regularly maintained in stock during the 1760's.

JOSEPH ROUX FILS AINÉ ET COMP.

Ingenieurs hydrographes, sur le Port vers St Jean,

Font et Vendent toutes sortes de Boussoles, Compas d'azimuth et autres, sabliers de toutes qualites, Sextans, Octans, Quarts de non ante, Fleches, Telescopes, Lunettes acromatiques de differentes longueurs Lunettes de nuit, Lorgnettes d'Opera, Compas a pointer, Echelles Anglaises, Etuis de Mathematique.

Ils sont assortis en toiles et etoffes de laine et de cotton pour les Pavillons ainsi qu'en Portulans, plans de Port et Cartes hydrographiques de tous les auteurs quelconques.

A MARSEILLE

Situated between the narrow Quai du Port and the rue Lancerie (later renamed "rue de la Loge"), the shop was one of a number of similar waterfront establishments catering to the professional requirements of the itinerant mariners who called at Marseille from ports throughout the Mediterranean and the Atlantic.

In 1883, Louis Brès, reminiscing about the colorful businesses to be found along the Quai du Port in former times, described a hydrographer's shop in a way that no doubt applied as much to the one owned by Joseph Roux as to any other:

Their little shops had a physiognomy of their own. The narrow shop window was encumbered with compasses, octants, pamphlets, compass cards, charts and marine glasses. Inside one descried in the cool shade the multi-colored bunting of flags, which gave to the shop a mysterious decoration; while a ray of sunlight shone on the glistening bowl of a compass and rested on the copper arms of some bizarre nautical instrument, so that the silhouette of the hydrographer appeared vaguely outlined in the most obscure corner.

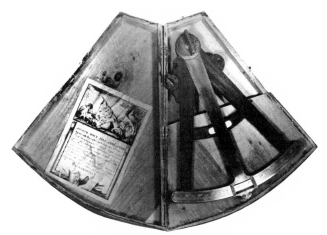

1. Mahogany-frame octant, circa 1760, made by Joseph Roux of Marseille, in the Peabody Museum instrument collection (M852).

Joseph's shop signs easily identified the spot to anyone from a distance or unfamiliar with the neighborhood. At first it could be found at the sign of the sea compass surmounted by a crown (*à la Boussolle Couronnée*) and later through the door flanked by two statuettes "of two officers of the merchant marine . . . in knee-breeches of nankeen, in coat of blue or chestnut color, white stockings, shoes with buckles, the three-cornered hat on their heads; one of them occupied in taking the elevation of the sun with an octant . . . in order to determine the ship's position; the other, the telescope leveled on the horizon. . . ." These "Little Men" eventually

1

became symbolic elements of the Roux family's hydrographic practice and figured on their trade cards for several generations.

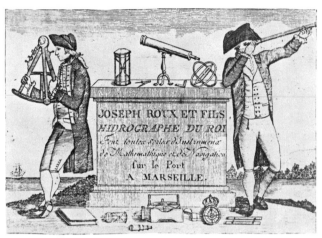

2. Joseph Roux trade card illustrating the two papier-mâché figures used for many years as his shop sign. Peabody Museum photograph collection.

Although his livelihood depended upon the manufacture and sale of instruments, Joseph Roux occasionally dabbled in artists' colors, a proclivity later honed to a fine edge by his son and then carried on with varying degrees of distinction by three grandsons and a granddaughter.

If Joseph were a prolific painter of ships and of nautical subjects it seems extraordinary that so few of his works have survived to be recognized. More likely, he painted only infrequently, being too concerned with the success of his professional endeavors to spare undue time to what in some quarters at that day was looked upon as a manifestation of idleness and unmanly behavior.

Sometime around mid-eighteenth century, Joseph Roux was warranted for the droit to call himself a "hydrographer to the King" and in 1764 published an ambitious folio of twelve Mediterranean sea charts, each measuring some 24 x 34 inches (61 x 86.4 cm.) and folded into a leather-bound volume of approximately 13½ x 24 inches (34.3 x 61 cm.). There was no engraved title page; instead, the pertinent information was contained within the decorative cartouche on the first plate: "CARTE DE LA MER MEDITERRANÉE | en Douze Feuilles | *Dediée a M^{GR}* LE DUC DE CHOISEUL *Colonel General des Suisses* | *et Grisons Ministre de la Guerre et de la Marine* | *Par son trés humble Serviteur Joseph Roux Hydrographe* | *du Roy, sur le Port a S^{t} Jean, a Marseille* | Avec Privilege du Roy | 1764."

This volume, like the venerable *English Pilot*, so well known to British mariners throughout the eighteenth century and beyond, appears to have enjoyed a long, useful, and healthy life. Two of the Peabody Museum's various copies were inscribed by their early owners not only as to the original price paid but also when and where they were purchased. One was acquired at Barcelona in June, 1796, for $8.00. The other was purchased at Genoa on February 7, 1826, for the sum of £20. The owner of the latter, Robert Knox, Jr., of Boston, commented on the worth of the volume: "These Charts are not correct as to Lat. & Long., but being

JOSEPH ROUX, the eldeſt Son and C^{o.}

King's Hydrographers and Engineers, on the quay Reboul's corner
Number 4. in MARSEILLES.

Make and ſell, all ſorts of Copper and Wood Compaſſes, obſervation's, variation's and Azimuth's; ditto Hour glaſſes of all qualities, Sextans ad hadley's Quadrants; Spying glaſſes of all ſizes; Flags and Linen cloth of all colour; Sea Chart for the Mediterranean and the Ocean, by all the Authors; Collection of Mediterranean's Harbour, and all ſorts of Inſtruments for Navigation.

3. Reproduction of a trade label used by Joseph Roux during the 1760's.

on a large scale & the headlands, bays, Mountains & Cities are so well delineated that I find it an excellent reference." A privately owned copy is known to have been bought for $5.00 at Newburyport, Massachusetts, as late as 1807. Three further copies, now at the National Maritime Museum, Greenwich, England, were used by the sailing masters of H.M.S. *Victory* in 1803 and 1805 and by Captain Brathwaite of H.M.S. *Shannon*.

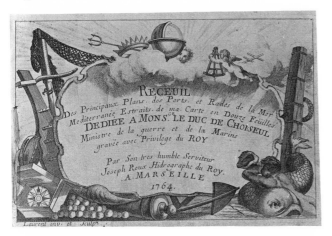

4. The title page of Joseph Roux's *Recueil* of 1764 which, through authorized and pirated editions, enjoyed a healthy publishing life of more than fifty years. Peabody Museum collection.

Simultaneously, in 1764, Joseph Roux published a smaller format digest which appeared in various editions for at least fifty-three years. The first edition was entitled: "Receuil [sic] | Des Principaux Plans, des Ports, et Rades de la Mer | Mediterranée Estraits de ma Carte en Douze Feuilles | Dediée a monsgr le duc de Choiseul | Ministre de la guerre et de la Marine | gravée avec Privilege du roy | Par Son tres humble Serviteur | Joseph Roux Hidrographe du Roy, | a Marseille | 1764."

In surviving copies of this edition the number of plates vary from sixty-five to 121, the latter number being more common in the edition of 1779 (published "a Genes [Genoa] chez Yves Gravier Libraire | sous la Loge de Banchi 1779"). Another edition of the *Recueil* appeared in 1795, two years after Joseph Roux's death, again with 121 plates, but this time published "a Livourne [Leghorn] chez François Natali Rûe Genois."

About the same time, Jean-Joseph Allezard, formerly a captain in the French navy, published under his own name a digest of an extremely similar nature, with only minor variations, as a "nou-veau recueil," followed in 1804 by another entitled "Recueil | De 163 des principaux Plans des Ports et Rades de la | Mediterranée, dont 40 ont été dernièrement publiés par Jean Joseph Allezard ancien Capitaine de Marine, | et plusieurs des autres corrigés." This, like Roux's 1779 edition, was published at Genoa by Yves Gravier Libraire. Another made its appearance at Leghorn in 1817, not including a pirated, reengraved version lacking title page, imprint, or even stamping on the spine. One further, undated variant, containing 153 plates, was published at "Livourne Chez Pre Meucci." Undoubtedly there were others as well.

All these editions are strikingly similar, especially with respect to the rococo cartouche on their title pages, first cut by "Laurent inv. et Sculp" but burnished and reengraved as necessary to accommo-

5. The title page of a pamphlet printed for Joseph Roux, describing the use of a Hadley's Quadrant, also known as an octant. Peabody Museum collection.

date changing demands. The Peabody Museum owns one other, undated, variant of the *Recueil*, probably issued about the time of the French Revolution, containing 153 plates and retaining portions of the wording of the 1764 title page (although re-engraved) with some interesting changes. "Gravée avec Privilege du ROY" is omitted as a consequence of the Revolution, although Roux has still retained his droit as "Hidrographe du Roy," the whole claimed as a "Nouvelle edition Corrigée et Augmentée."

Two of Joseph Roux's paintings are to be found in the Peabody Museum collection. Both are in oils, a medium shunned by all the others in his family save his grandson Frédéric, who only infrequently employed them himself. Both are dated 1781.

Neither one suggests the work of a man still experimenting or discovering his palette, for both are competent, bold expressions of their day. Let any beginner tackle a moonlit scene, such as his depiction of the action between *Bonhomme Richard* and *Serapis*, with such strength or control. Obviously, he had mastered his technique long before either painting was either conceived or executed. Obviously, too, he came from a family of mariners, a fact which the recent genealogical investigations by A. Fribourg have established beyond the shadow of a doubt.

Joseph Roux, hydrographer at Marseille, thus became the artistic patriarch of a dynasty of marine painters, the inspiration for a tradition that spanned more than a century during the Golden Age of sail.

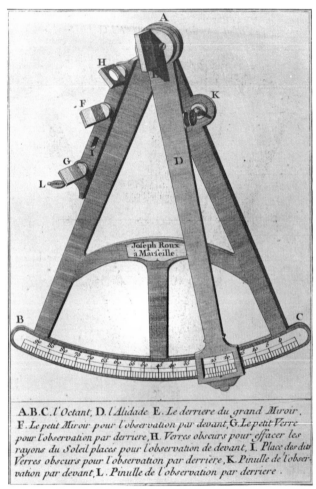

6. Frontispiece of the pamphlet printed for Joseph Roux which described the use of an octant, an instrument used at sea to determine latitude positions. Peabody Museum collection.

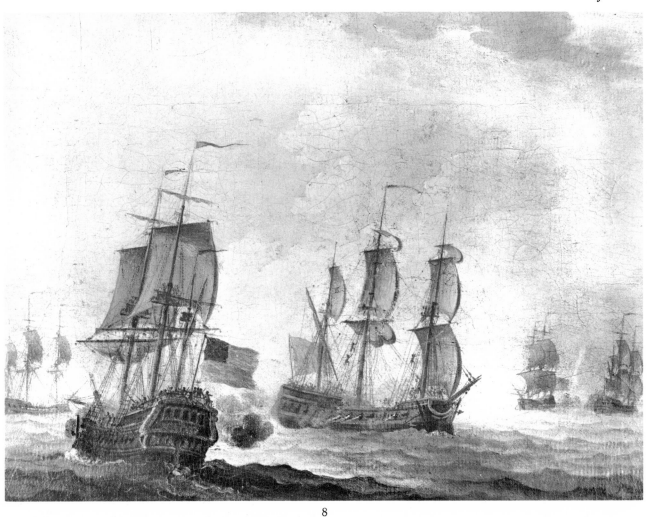

8

7. BONHOMME RICHARD *vs* SERAPIS [American and British frigates]. Oil. 10¾ x 14¾ in. (27.3 x 37.5 cm.). Signed, l.r., "J. Roux 1781." Gift, Marion Vernon Brewington, 1950.　　M6850
See color plate facing page 6.

On September 23, 1779, while cruising off Flamborough Head in company with a small squadron of naval vessels and privateers, the American forty-gun frigate *Bonhomme Richard,* commanded by John Paul Jones, fell in with a British convoy from the Baltic. *Bonhomme Richard* engaged the principal escorting frigate, *Serapis,* 44, Captain Richard Pearson. After a desperate action lasting more than three hours, *Serapis* struck her colors even though *Bonhomme Richard* was hulled and subsequently sank.

8. Naval Engagement Between a British East Indiaman and a French Warship. Oil. 10¾ x 14¾ in. (27.3 x 37.5 cm.). Signed, l.r., "J. Roux 1781." Gift, Marion Vernon Brewington, 1951.　　M6903

Typical of the period, these ships are high, bluff-bowed, and resplendent with ornate stern carvings. Courses have been brailed up, as was normal in times of action, but the jibboom and the outboard end of the bowsprit of the Frenchman have been shot away, forcing him to set his forecourse in order to maintain maneuverability.

ANGE-JOSEPH ANTOINE ROUX (1765–1835)

BORN in Marseille on March 6, 1765, Ange-Joseph (*not* Joseph-Ange) Antoine Roux grew to maturity in his father's hydrographic shop, where most likely he also apprenticed, and enjoyed daily access to the odors, sights, and sounds of the Marseille waterfront. A hydrographer's shop in any

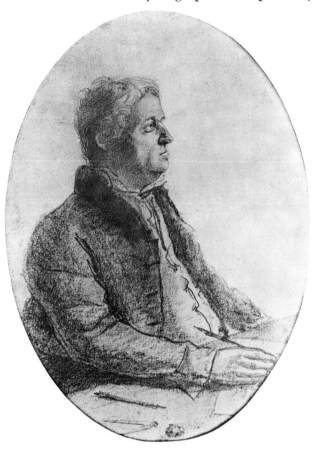

9. Portrait of Ange-Joseph Antoine Roux, sketched by le Chevalier de Trompbrillaint, October, 1830. Peabody Museum photograph collection.

bustling port, let alone one at Marseille, was always a focal point for resident as well as transient mariners. There were charts to be purchased and their relative merits to be discussed, often at some length and occasionally with considerable fervor. The latest navigational device on the shelf rarely failed to become an object of intense speculation or argument. Signaling systems might be debated with respect to colors of flags, specific hoists for recognition, and the dimensions of individual flags for op-

timal visibility at a distance. Stories were swapped, experiences were shared, and grievances were sounded.

In such an atmosphere, a bright, young lad picked up an abundance of nautical lore. It naturally would reenforce his eagerness to learn about the vessels that produced such characters as came regularly to his father's shop. He had not far to go: a few steps to the edge of the quays just outside the door.

It was also to and from the same harbor that many of his family and connections sailed. The Roux clan was large, both by blood relationship and by spiritual or professional affiliation. They were mainly mariners themselves, and they added significantly to young Antoine's curiosity about the world around him.

There can be no doubt that from an early age he shared in the experiences generated by his father's associations and by the workaday activities of his surroundings. One suspects, although it is highly unlikely that anyone now will ever know for sure, that his friends and relations took him along on many a day's cruise of Mediterranean waters, perhaps for the advancement of his general education, perhaps simply for pleasure, perhaps to gratify his wish to learn more about ships and shipping.

The point is that sometime, somehow, in his adolescent years, Antoine Roux learned about all kinds of vessels—what they looked like, their peculiarities, how they were built, exactly and precisely how they were rigged, what it took to sail them, the effects of wind and water upon them, how they behaved in a seaway during a calm or during a vicious chop, and the physical principles which caused them to sweep majestically over the horizon from places unknown into his own view.

While Antoine Roux was becoming a man, European ship portraiture also had been maturing. The latter had been developing slowly, yet by the mid-1780's it was beginning to come into its own. Throughout the eighteenth century there had been British and continental artists who had depicted ships at sea and in harbor, yet their subjects nearly

6

7. *Bonhomme Richard vs. Serapis*, by Joseph Roux, 1781

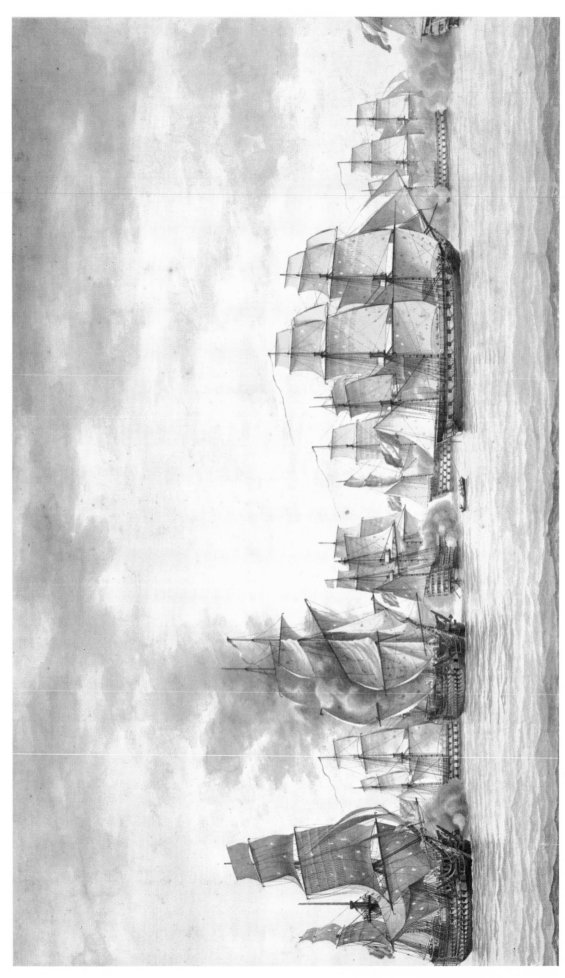

13. Naval Engagement Between the British and French Fleets in Algeciras Bay, 1801, by Antoine Roux

always reflected the heroic images of notable events —unusual single ship actions, naval engagements between fleets, and, from time to time, views of unidentified, anonymous shipping dropping up and down a river with the tide. Only rarely did these artists depict the more mundane and unglamorous identified merchant vessels going about their routine business.

Artists, then as now, like anyone else, earned their livings by catering to the dictates of popular taste. Why paint a common subject, such as the portrait of an ordinary merchantman, except for practice and perfection of artistic style, unless someone were willing to pay for it? Until the last quarter of the eighteenth century there was little market for anything but the romantic.

One market for the identified, individual ship portrait was the occasional mariner who, having undergone a frightful experience during a storm or some other traumatic event at sea, was inclined to express his gratitude for salvation by commissioning an *ex voto* painting for presentation to the Virgin. Roman Catholic churches throughout southern Europe abound in such devotional offerings— from paintings to models. The Chapels of Notre Dame de la Garde at Marseille, Notre Dame de la Garoupe at Antibes, and St. Anne's at Saint Tropez are examples. It was in such as these, perhaps, that Antoine Roux got his start.

There may be earlier examples of Roux's work floating about somewhere, but the earliest known to the author, none of which are *ex voto* pictures, supposedly date from 1787. These may be divided into two categories: a single sketch actually signed and dated, and a series of watercolors described on their mats as "Dessiné en l'année 1787 à bord du Vaisseau 'Le Trusty' de 60 canons Anglais de nation." The former was owned in the 1920's by M. Laurent Chambon and was reproduced on page 67 of the Marine Research Society's *Ships and Shipping*, published in Salem, Massachusetts, in 1925. The latter have been in a private Swiss collection. The author has never seen the originals but only the most cursory glance at photographs of them is necessary to tell that they could not possibly have come from the same hand during the same year.

The single sketch shows the stern, spars, and rigging of an unidentified man-of-war. It is a stiff,

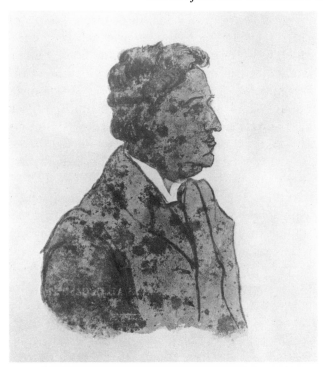

10. Wash sketch of Ange-Joseph Antoine Roux, by an unidentified artist, in the Peabody Museum collection (M3143).

mechanical drawing, one so precise it could have illustrated a treatise on the art of rigging. Antoine Roux at the time would have been twenty-two years old (by which age his three sons would have become almost as proficient in their own artistic endeavors as Antoine himself became throughout his entire career). One gets the feeling that at this stage in his career his hydrographic disciplines had caused him to develop into a better draftsman than artist. The "Trusty" series, however, must date nearly a decade later, both for stylistic reasons and for anomalies of rigging. Dolphin strikers, for instance, were hardly known, if at all, in 1787.

Roux's artistic metamorphosis, nevertheless, seems to have come about within another two or three years, as exemplified by one of his most beautiful sketchbooks, dated 1790, in the Peabody Museum collection. The rigid draftsmanship was transformed into a much looser, more flowing style he was to perfect during the next forty years.

"Antoine Roux," wrote Louis Brès in 1883, "was the creator in France of a new kind of painting— the ship portrait—a style somewhat neglected today, but which had, during more than half a century, a very great vogue in our seaports. Who does

not recall having seen in the counting houses of our shipowners, those frames in which was represented in water-colors with a minute fidelity and a remarkable truthfulness of appearance, some vessel of commerce, a three-master, a brig, a schooner, running off, all sail set, and underneath it, a black band on which stood out in beautiful white letters the name of the ship, that of the captain and that of the owner. The most remarkable of these portraits were painted by members of the Roux family."

Antoine Roux's technique for rendering water changed perceptibly sometime about 1805-1806. Gone, except when illustrating extremely rough or high seas, were the formal, high-crested wavelets so typical of his early work. In their place were softer, less stylized, and less artificial waves more in keeping with their appearance in nature. His manner of depicting hulls and rigging changed remarkably little over the years; his sense of composition seems to have been part of his genius from the beginning. He was becoming less the "ship portraitist" than a full-fledged "painter of marines."

Through observation of a large number of water-colors by Antoine Roux, originals and photographs both, a pattern begins to emerge with respect to his manner of signing. Almost always to be found at the lower right-hand corner of each sheet, there are three predominant forms:

1790's-1802 "fait par Ante [or "Antne"] Roux"
1801-1830 "Ante [or "Antne"] Roux à Marseille"
1825-1835 "Ante [or "Antne"] Roux père à Marseille"

In addition, one discovers from time to time seemingly random numbers following the date of a painting, such as "1803 = 64." Exactly what this suggests is not certain, but the probability is that it was Roux's way of numbering his yearly output. His use of the system was sporadic, to say the least, in the same way many of us will start a diary but finally give up on it.

Antoine Roux, Louis Brès went on to comment nearly fifty years after the artist's death, was "an enormously prolific painter and always worked

with that conscience and that love of his art, which we find in his smallest pages. The shipowners of Marseille and the foreign captains, vied with each other in entrusting to him the task of reproducing their ships. The merchants upon leaving the assembly hall of the Exchange, where they came

11. [See the first catalogue entry under A-J Antoine.]

every day to attend to their business affairs, loved to have a look at the show window of the hydrographic painter, where some new piece of work was always on view. Soon after them it was the owner who came and brought his friends to judge of the resemblance, and together they would exclaim in surprise and then go into the shop to congratulate the painter. It was always the same way with each new ship picture."

On April 20, 1835, Antoine Roux died "from the results of an attack of cholera. Up to the last days of his green old age," Louis Brès concluded, "the painter-hydrographer was faithful to his charts and to his brushes. It was a pleasure to see this vigorous old gentleman in his shop with his affable and smiling face, and who, although deprived of one eye, still turned off so skilfully his portraits of ships and amused himself between times in sketching some typical street figure caught as he saw it through his half-open door. . . ."

8

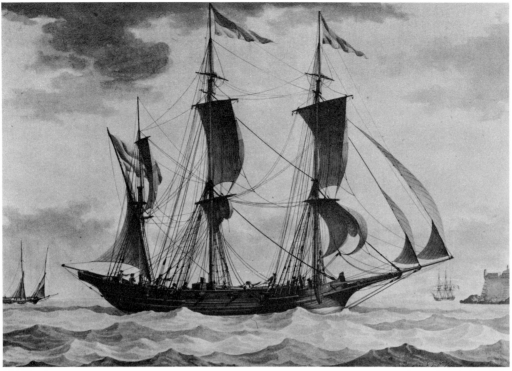

12

11. "Montaudis, Maison de Plaisance à Endoume." Watercolor. 10¼ x 12¼ in. (26 x 31.1 cm.). Unsigned, attributed to Antoine Roux. Inscription on reverse reads: "pièce très rare | Cabanne [Cabanon] des Roux | F. 2000." Also label of the original framer: "Pre Fois Delobre Doreur et Miroitier," Marseille, "Place Noailles No 28." Purchase, 1931. M3713

"Montaudis," or, literally, "my hovel," was the Roux holiday camp on the Pointe d'Endoume, a short distance southwest of the Old Port of Marseille, overlooking the Château d'If in the bay. The two figures are believed to be Antoine Roux, Jr. (holding the telescope) and Antoine Roux, the father.

12. French Armed Chebec. Watercolor. 13¾ x 20½ in. (34.9 x 52.1 cm.). Signed, l.r., "fait par Ante Roux Marslle 1800." Gift, Colonel Lawrence W. Jenkins, 1957. M9194

The earliest dated formal painting by Antoine Roux (excluding sketchbook work) in the Peabody Museum collection, this watercolor clearly demonstrates his already impeccable technique of rendering a vessel's hull and rigging. His treatment of the water, however, is mechanical and harsh, typical of his early style.

13. Naval Engagement Between the British and French Fleets in Algeciras Bay, 1801. Watercolor. 17¼ x 29½ in. (43.8 x 74.9 cm.). Signed, l.r., "Antne Roux à Marseille." No date. Gift, from the Richard Wheatland Collection, 1959. M10264 See color plate facing page 7.

A French fleet sent from Toulon to join forces with the Spanish division at Cadiz anchored off Algeciras when it was learned that a superior British force under Admiral Sir James Saumarez was cruising before Cadiz. In early July, 1801, Saumarez attacked the anchored French fleet, but a combination of failing wind and mishap caused him to withdraw to Gibraltar for repairs. A second, later engagement, this time with the combined French and Spanish fleets, proved victorious for the British.

9

14

14. Unidentified Brig in a Storm. Watercolor. 18½ x
24¼ in. (47 x 61.6 cm.). Signed, l.r., "1802 Ant^e
Roux à Marsei[lle]." Gift, Leonard E. Opdycke,
1977. M17076

A brig of unknown nationality scuds before a gale. Waves are
breaking over her quarterdeck, an extremely dangerous situation
which could lead to her being pooped. This watercolor is reminis-
cent of *ex voto* pictures, painted for mariners, who had been
miraculously saved at sea, as offerings to the Virgin.

15. MARIA. "Maria Cap^tn Joseph Saunders of Boston
Nov^ber 1804" [American snow]. Watercolor. 14⅞
x 19⅞ in. (37.8 x 50.4 cm.). Signed, l.r., "Ant^ne
Roux a Marseille 1804." Bequest, Professor
Charles S. Sargent, 1927. M3168

Maria was built at Falmouth (now Portland), Maine, in 1803.
She measured 182 tons, 79' 10" length, 22' 10" extreme breadth,
and 11' 5" depth of hold. Her Boston owners at this time were
John T. Sargent, Daniel Sargent, Sr., Daniel Sargent, Jr., and
Ignatius Sargent. Note that she is armed to prevent capture by
corsairs of the Barbary pirates.

16. ULYSSES. "Ship Ulysses Captain W^m Mugford
of Salem in Latt^d 41° 40' North & Long^de 65° 0'
West of London February the [] 1804" [Amer-
ican ship]. Watercolor. 16¼ x 22¾ in. (41.3 x 57.8
cm.). Signed, l.r., "Ant^e Roux Marseille 1804."
Bequest, Henry Mugford, 1899. M174

Ulysses was built at Haverhill, Massachusetts, in 1798 and
measured 340 tons, 100' 5" length, 27' 9" extreme breadth, and
13' 10" depth of hold. She was owned by William ("Billy") Gray
of Salem.

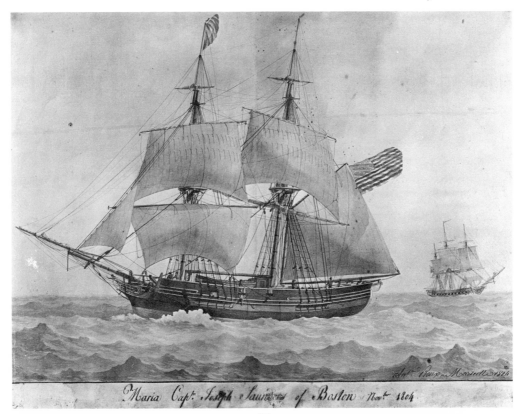

Maria Capt. Joseph Saunders of Boston Novr 1804.

15

Ship Ulysses Captain Wm Mugford of Salem in latt. 41° 10' North & Longd 66°...of London February the...1804

16

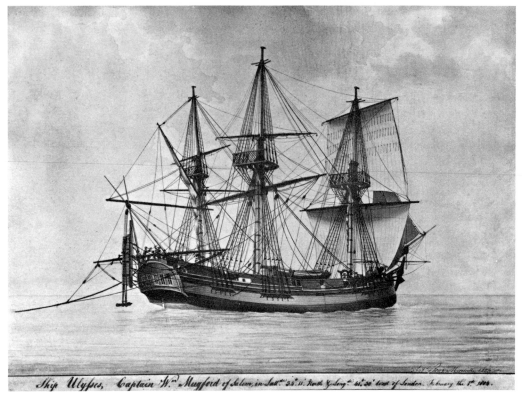

Ship Ulysses, Captain Wm Mugford of Salem, in Latt.d 35.11. North & Long.t 41.30' West of London. February the 1st 1804.

17

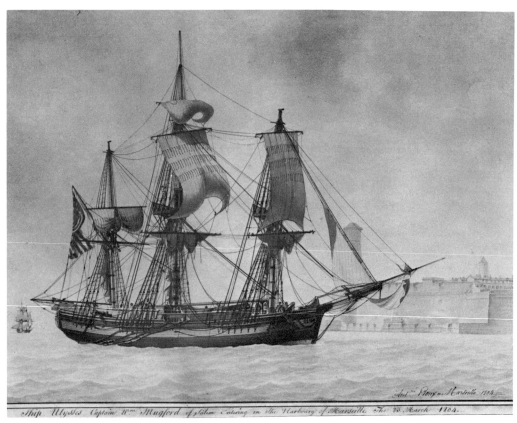

Ship Ulysses Captain Wm Mugford of Salem Entering in the Harbourg of Marseille The 28 March 1804.

18

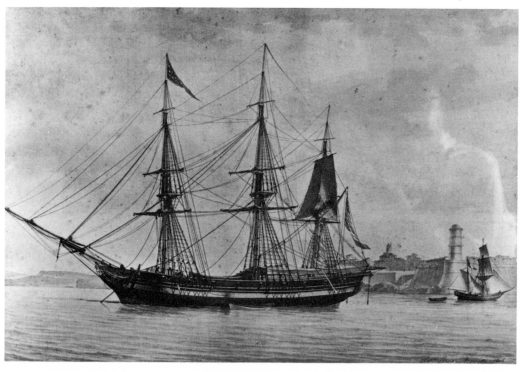

20

17. ULYSSES. "Ship Ulysses, Captain W^m Mugford of Salem, in Latt^de 34° 11' North & Long^de 41° 31' West of London, February the 1^st 1804" [American ship]. Watercolor. 16½ x 22¾ in. (41.9 x 57.8 cm.). Signed, l.r., "Ant^e Roux Marseille 1804." Bequest, Henry Mugford, 1899. M175

During the storm depicted in the preceding picture, *Ulysses* lost her rudder. This watercolor illustrates the ingenious jury rudder rigged by Captain Mugford, for which he later received a gold medal from the American Philosophical Society at Philadelphia. The Peabody Museum also owns a hull model of *Ulysses*, donated by Captain Mugford prior to 1821, which shows the same device in three-dimensional form.

18. ULYSSES. "Ship Ulysses Captain W^m Mugford of Salem Entering in The Harbourg [sic] of Marseille The 23 March 1804" [American ship]. Watercolor. 16¼ x 22½ in. (41.3 x 57.1 cm.). Signed, l.r., "Ant^ne Roux a Marseille 1804." Bequest, Henry Mugford, 1899. M176

The last of the three watercolors showing *Ulysses*, the ship is here illustrated sailing past Fort St. Jean into the Old Port of Marseille, which figures prominently in so many pictures by members of the Roux family.

19. Unidentified American Frigate Entering a French Port. Watercolor. 17¾ x 24 in. (45.1 x 61 cm.). Mutilated signature, l.r., "Ant^e Roux." No date. Gift, Henry S. Streeter, 1965. M12303
See color plate facing page 14.

It is possible that this is the United States frigate *Boston*, built at Boston in 1799 for the federal government by means of a subscription fund raised among a group of prominent Boston shipowners and merchants. The port has not been identified, but if the vessel is *Boston* the harbor could as well be in the West Indies as in the Mediterranean.

20. AMERICA [American ship]. Watercolor. 19 x 26¼ in. (48.2 x 66.7 cm.). Signed, l.r., "Ant^ne Roux a Marseille 1806." Gift, Mrs. Bowdoin B. Crowninshield, 1949. M6581

The fourth ship of the name owned by George Crowninshield & Sons of Salem, *America* was built in Salem by Retire Beckett in 1804. She measured 473 tons, 114' length, 30' 8" extreme breadth, and 15' 4" depth of hold. For many years she was active in trade with the Mediterranean, Mocha, Aden, the Isle of France (Mauritius), and Sumatra. During the War of 1812 she became a noted Salem privateer. Moves after the war to convert her back into a merchantman failed, and she ended her days as a hulk sold at auction to the ship-breakers in 1831.

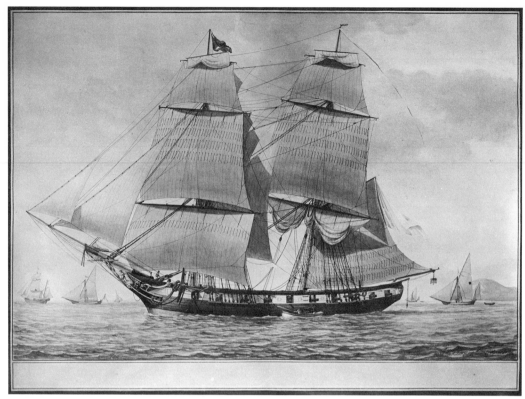

21

21. LA TACTIQUE [French armed brig]. Water-color. 17 x 23¾ in. (43.2 x 60.3 cm.). Signed, l.r., "Antᵉ Roux a Marseille 1807." Purchase, 1929.
M3469

La Tactique was built at St. Malo in 1792. The strange device rigged under the boom may be explained in two ways: 1) as a *bouée de sauvatage*, a life preserver ready to slip into the sea at a moment's notice, or 2) as an arrangement used for hanging fresh meat to be kept cool and out of the reach of pilferers. About 1805-1806, Antoine Roux changed the manner in which he traditionally had delineated water. It no longer had the stiff, structured look of previous years, heralding a style change he was to embrace for the remainder of his career.

22. LOVELY MATILDA. "Ship Lovely Matilda of Philadelphia Capᵗⁿ Benjⁿ Huggins" [American ship]. 15¾ x 21¾ in. (40 x 55.2 cm.). Signed, l.r.,

"Antᵉ Roux au Marseille 1808." Inscription on reverse: "Mʳ Ducoin négᵗ à Bordeaux de 1770 à 1820." Gift, Charles H. Taylor, 1938.
M6411

Lovely Matilda, a ship of 231 tons, was built at Philadelphia in 1805. This is one of Antoine Roux's outstanding pictures—the crisply delineated hull, the press of carefully shaded canvas aloft, and the figures working on deck all contribute to the Roux genius.

23. TOPAZ. "Topaz of Newburyport Capᵗⁿ Moses Knight" [American snow]. Watercolor. 16½ x 22¾ in. (41.9 x 57.8 cm.). Signed, l.r., "antⁿᵉ Roux a Marseille 1808." Gift, George Augustus Peabody, Robert Osgood, and C. S. Rea, 1917.
M2233

Topaz was built at Newbury, Massachusetts, in 1807. She measured 213 tons, 83′ 1″ length, 24′ 4″ extreme breadth, and 12′ 2″ depth of hold. Her owner was Benjamin Peirce of Newburyport.

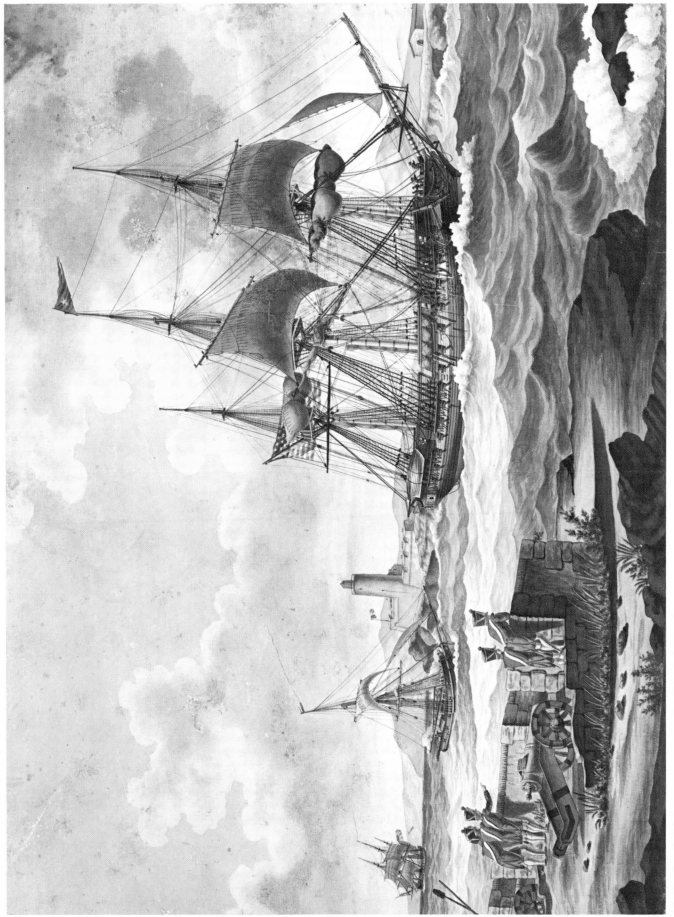

19. Unidentified American Frigate Entering a French Port, by Antoine Roux, *circa* 1805

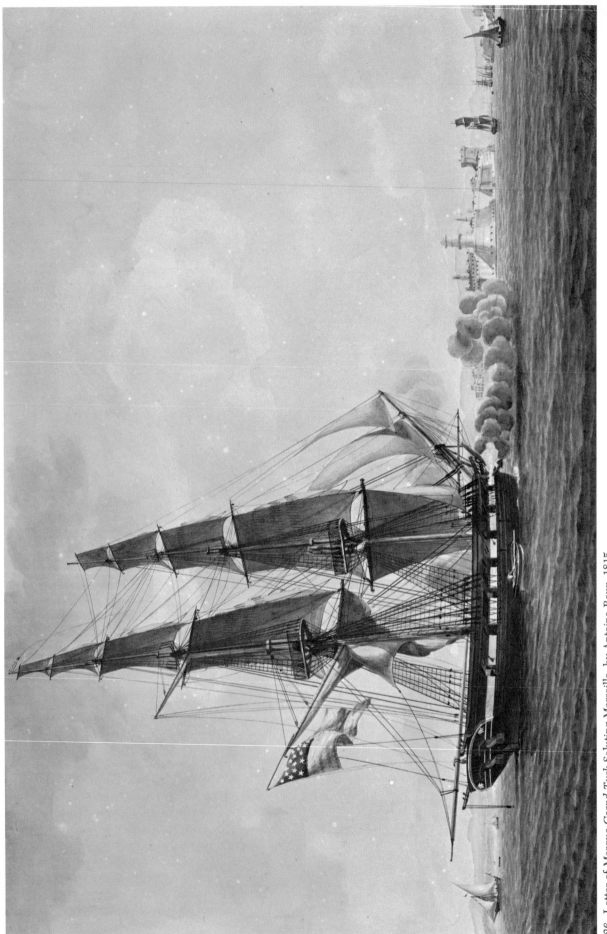

26. Letter of Marque *Grand Turk* Saluting Marseille, by Antoine Roux, 1815

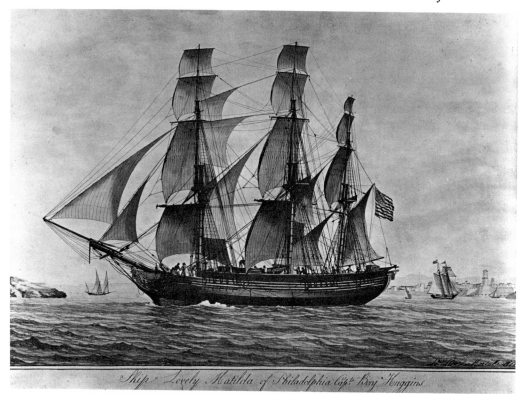

Ship Lovely Matilda of Philadelphia Capt Benj Huggins

22

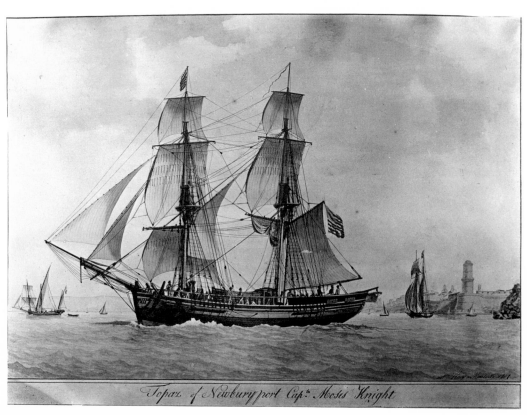

Topaz of Newburyport Capt Moses Knight

23

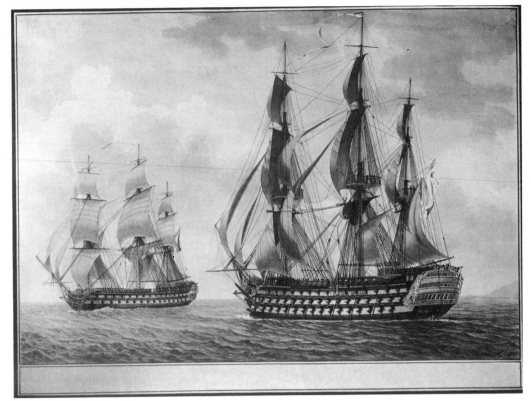

24

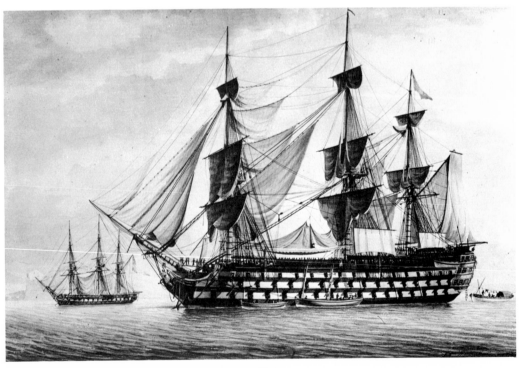

25

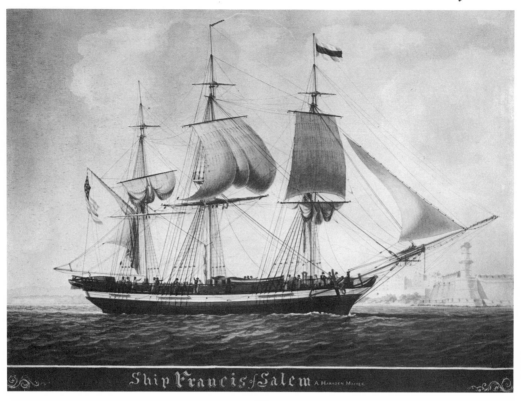

Ship Francis of Salem A. Haraden Master

27

24. COMMERCE DE PARIS [French ship of the line]. Watercolor. 17 x 23¼ in. (43.1 x 59 cm.). Signed, l.r., "Ante Roux a Marseille 1809." Purchase, 1929. M3470

A big three-decker with ornate stern and quarter galleries, *Commerce de Paris,* built in 1804, maneuvers on the starboard tack toward an unidentified French two-decker running before the wind.

25. LE WAGRAM [French ship of the line]. Watercolor. 13¾ x 18¾ in. (34.9 x 47.6 cm.). Signed, l.r., "Ante Roux à Marseille 1811." Purchase, 1931. M4267

A beautiful study of another French three-decker, Antoine's son François later made a fair copy of this original as part of the series of maritime paintings he executed for the Musée de la Marine. It is illustrated (reversed) as Plate 1 in Admiral Pâris' *La Marine Française de 1792 à nos Jours* (Paris, 1885).

26. GRAND TURK. "The Letter of Marque Grand Turk, of 14 Guns Wm Austin Comder Saluting Marseilles, 1815" [American brig]. Watercolor. 17½ x 24¼ in. (44.5 x 61.6 cm.). Signed, l.r., "Ante Roux à Marseille 1815." Gift, Joseph Abbott Sibley, 1906. M790

See color plate facing page 15.

Probably the most dramatic of all Antoine Roux's paintings in the Peabody Museum collection is this one. *Grand Turk* was built at Wiscasset, Maine, in 1812 specifically as a privateer and was bought in Boston by a group of Salem men who successfully managed her as a letter-of-marque for five cruises. After the war she was acquired by William Gray and was sent off on a merchant voyage to the Mediterranean when this (and one other known watercolor of her by Roux) was painted.

27. FRANCIS. "Ship Francis of Salem A. Haraden Master" [American ship]. Watercolor. 16½ x 22¾ in. (41.9 x 57.8 cm.). Signed, l.r., "Ante Roux à Marseille 1816." Original title border painted out and reworked. From the Essex Institute, 1908. M1017

Francis was built in Salem in 1807. She measured 297 tons, 96' length, 25' 10" extreme breadth, and 12' 11" depth of hold. Owned by Joseph Peabody (whose house flag flies from the fore truck) and Gideon Tucker of Salem, the ship made voyages to the Mediterranean, India, and Sumatra. This watercolor was painted for the ship's clerk, Ephraim Emmerton, Jr., who paid thirty-six francs for it, including the frame, an amount exactly equivalent to another purchase of his at Marseille: one pair of "fine casimere Pantaloons."

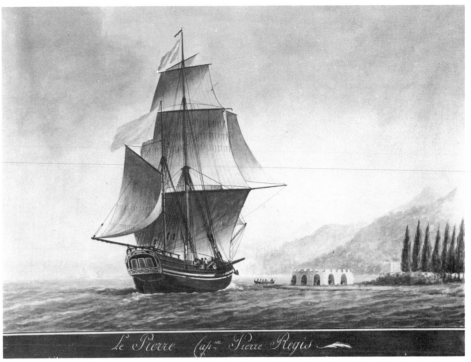

Le Pierre Cap.ne Pierre Regis

28

28. LE PIERRE. "Le Pierre Cap^ne Pierre Regis" [French ketch]. Watercolor. 16¾ x 23 in. (42.6 x 58.4 cm.). Signed, l.r., "Ant^ne Roux a Marseille 1816." Gift, from the Richard Wheatland Collection, 1976. M17030

A small vessel apparently engaged in the coastal Mediterranean trade, the rig classified her locally as a "bombarde."

29. EUNICE [American brig]. Watercolor. 18⅝ x 25¾ in. (47.2 x 65.4 cm.). Unsigned, attributed to Antoine Roux, and believed to have been painted in 1817. Gift, George Augustus Peabody, 1909.
 M1380

Eunice was built at Barnstable, Massachusetts, in 1803 and measured 145 tons, 71′ 10″ length, 22′ 6″ extreme breadth, and 11′ 3″ depth of hold. Her owners were Moses Townsend and Joseph Ropes of Salem; her master was Penn Townsend. *Eunice* was condemned in England about 1822 on her way home from Penang. The unusual operation illustrated by this painting was long thought to have taken place on the island of St. Paul in the Indian Ocean, but in fact it occurred at La Ciotat, some thirty-odd kilometers southeast of Marseille, and was at the time a common procedure there. Vessels which required repair to the hull had huge casks constructed around them and were rolled ashore.

30. LA BRISEIS. "Corvette la Briseis Commandée par le Chevalier Abadie—1818" [French ship]. Watercolor. 16¼ x 22¼ in. (41.3 x 56.5 cm.). Signed, l.r., "Ant^e Roux a Marseille 1818." Purchase, 1938.
 M4697

La Briseis flies the white flag of the Restored Monarchy of 1814-1830.

18

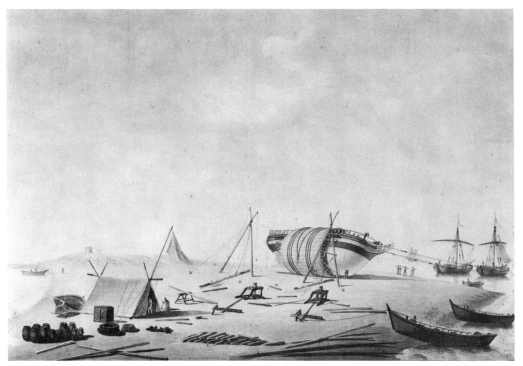

29

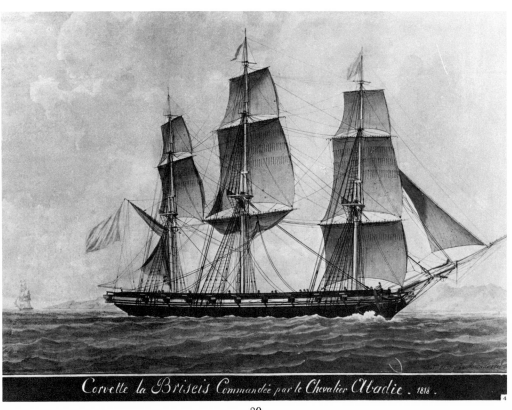

Corvette la Briseis Commandeé par le Chevalier Abadie. 1818.

30

31

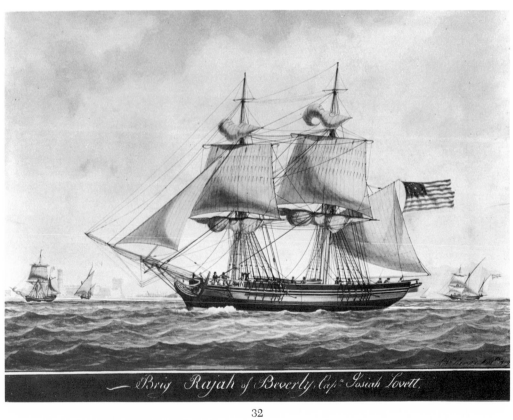

Brig Rajah of Beverly, Cap.ᵗ Josiah Lovett.

32

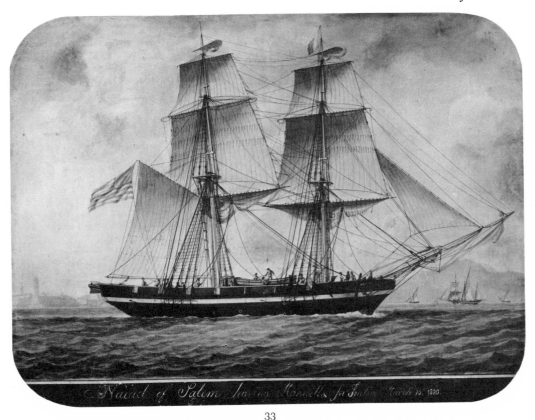

Naiad of Salem leaving Marseille for India, March 15, 1820.

33

31. Brig Entering Harbor. Watercolor. 6¾ x 10¼ in. (17.2 x 26 cm.). Signed, l.r., "Ant^ony Roux 1818." Gift, Charles H. Taylor, 1972. M15238

The signature is not that of Antoine Roux, although the style is similar to his sketchbook work. Inasmuch as the quay and lighthouse appear to be those at Havre (and as an almost illegible inscription at the bottom center may perhaps read: "Le Phare Havre"), this watercolor should probably be attributed to Antoine's second son, Frédéric, who began painting at Havre about 1835.

32. RAJAH. "Brig Rajah of Beverly, Cap^tn Josiah Lovett" [American snow]. Watercolor. 17¼ x 23½ in. (43.8 x 59.7 cm.). Signed, l.r., "Ant^e Roux à Mars^lle 1819." Deposit, 1977. D-500-101

The brig *Rajah* (technically a "snow" because of the small trysail mast stepped just abaft the mainmast) was built at Newbury, Massachusetts, in 1818. She measured 249 tons, 89′ 10″ length, 25′ 2½″ extreme breadth, and 12′ 7¼″ depth of hold. Originally hailing from Beverly, Massachusetts, *Rajah* was sold to New Bedford owners in March, 1830.

33. NAIAD. "Naiad of Salem leaving Marseille for India, March 15, 1820" [American snow]. Watercolor. 16¼ x 22¼ in. (41.3 x 56.5 cm.). Signed, l.r., "Ant^e Roux à Marseille 1820." Gift, Miss Mary O. Hodges, 1902. M144

Naiad was built in Haverhill, Massachusetts, in 1817, and measured 259 tons, 93′ 9″ length, 25′ extreme breadth, and 12′ 6″ depth of hold. Her principal owner in Salem was Pickering Dodge. She was commanded by Captain Nathaniel Osgood.

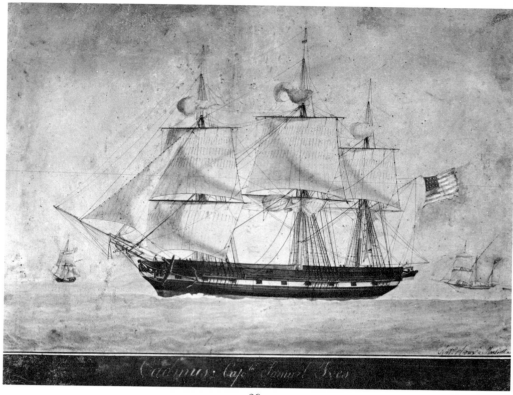

36

34. SOUTH CAROLINA. "South Carolina, of New-Orleans, Captn W. F. Wyer, leaving Marseilles for New Orleans, Sepr the 4th 1819" [American snow]. Watercolor. 17 x 23¼ in. (43.2 x 59 cm.). Signed, l.r., "Ante Roux a Marseille 1820." Gift, from the Richard Wheatland Collection, 1976. M17029 See color plate facing page 30.

South Carolina, a vessel of 245 tons, was built at Philadelphia in 1809. Her owners at this time were James H. Shepherd, William F. Wyer (the captain), Rezin D. Shepherd, and Judah Touro of New Orleans.

35. BARBARA. "Barbara" [American snow]. Watercolor. 16¾ x 23¼ in. (42.5 x 59 cm.). Signed, l.r., "Ante Roux à Marseille 1822." Gift, Charles H. Taylor, 1938. M6412

Barbara was built at Boston, also her port of registry, in 1818. She measured 260 tons, 94' 6" length, 24' 9" extreme breadth, and 12' 4½" depth of hold. Her master at this time was William Stevenson, and her owners were William J. Loring, Caleb Loring, and John A. Cunningham, all of Boston.

36. CADMUS. "Cadmus Captn Samuel Ives" [American ship]. Watercolor. 17¼ x 23½ in. (43.8 x 59.7 cm.). Signed, l.r., "Ante Roux à Marseille 18[2]2." Gift, Jeremiah W. Ferguson, 1906. M791

Cadmus was built by Thatcher Magoun at Medford, Massachusetts, in 1816. She measured 320 tons, 103' 7" length, 26' 3" extreme breadth, and 13' 1¼" depth of hold. She was owned in Boston by Benjamin Rich, et al.

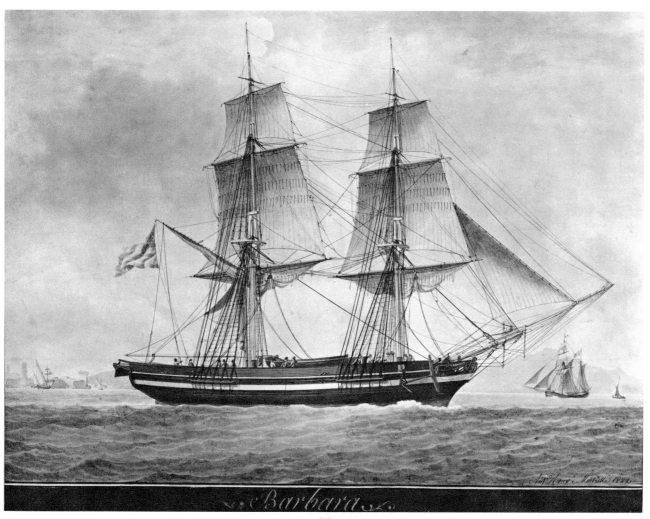

35

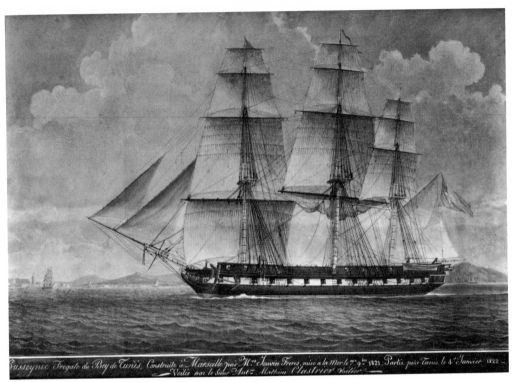

37

38

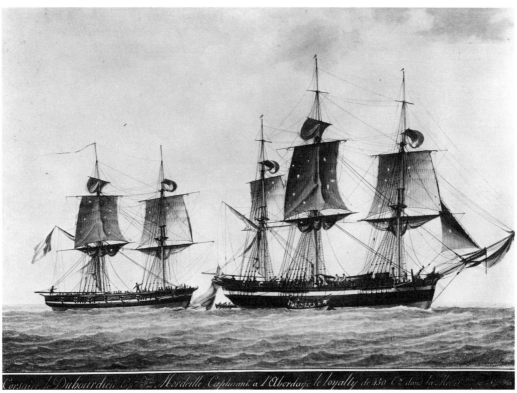

39

37. HUSSEYNIE. "Husseynie Fregate du Bey de Tunis, Construite à Marseille par M^rs Jouvin Freres, mise a la Mer le 7 9^bre 1821, Partie pour Tunis, le 4^s Janvier 1822—Voilée par le Sieur Ant^ne Mathieu Clastrier Voilier" [Tunisian frigate]. Watercolor. 24 x 34½ in. (61 x 87.6 cm.). Signed, l.r., "Ant^e Roux à Marseille 1822." Gift, Charles H. Taylor, 1932. M3773

A forty-four-gun frigate of 1,039 tons, built at Marseille, the inscription reads in translation: "Frigate Husseynie of the Bey of Tunis, built at Marseille by Messrs. Jouvin Brothers, launched 7 September 1821, departed for Tunis, 4 January 1822—sails made by Antoine Mathieu Clastrier, Sailmaker."

38. "Vue de la ville de Montevideo, prise de la mer, distance 1/2 mille, le soir." Watercolor. 4 x 24½ in. (10.2 x 62.2 cm.). Unsigned, attributed to Antoine Roux. Dated 1822. Purchase, 1931. M3754

Although Antoine Roux is not known to have traveled to Montevideo, he is believed to have executed this detailed waterfront view from sketches provided him at Marseille by one of his seafaring clients.

39. LE DUBOURDIEU. "Corsaire, Le Dubourdieu, Cap^n F^cois Mordeille, Capturant a L'Abordage le Loyalty de 450 T^x dans la Medit^née en 1810" [French privateer brig]. Watercolor. 17½ x 23⅝ in. (44.4 x 60 cm.). Signed, l.r., "Ant^e Roux à Marseille 1823." Gift, from the Richard Wheatland Collection, 1977. M17129

"Privateer *Le Dubourdieu*, Captain François Mordeille, Capturing by Boarding the *Loyalty* of 450 tons, in the Mediterranean in 1810." A retrospective scene, this is one of two paintings known to have been painted by Antoine Roux of Mordeille's exploits during the Continental Blockade of 1810. *Loyalty* hailed from Bristol, England.

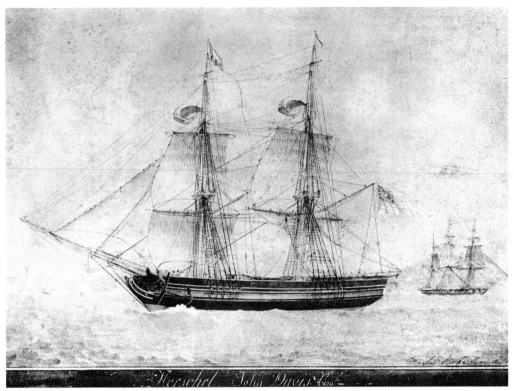

40

40. HERSCHEL. "Herschel John Davis Com^der^" [American snow]. Watercolor. 16 x 22½ in. (40.6 x 57.2 cm.). Signed, l.r., "Ant^e^ Roux à Marseille 1823." Gift, Charles H. Taylor, 1938. M6413

Herschel was built at Kennebunk, Maine, in 1822 and measured 258 tons, 94′ 7″ length, 24′ 10″ extreme breadth, and 12′ 5″ depth of hold. Her owners were Francis Watts of Boston and George Lord and Ivory Lord of Kennebunk. She was abandoned at sea in September, 1836, when she became waterlogged fifty miles off Cape North, Newfoundland.

41. LA VILLE DE GENÈVE. "Brig La Ville de Genéve, Cap^ne^ Barthelemy Maurin" [French snow]. Watercolor. 16½ x 23¼ in. (41.9 x 59 cm.). Signed, l.r., "Ant^e^ Roux pere à Marseille 1826." Purchase, 1938. M4699

Shown with her topmasts sent down, *La Ville de Genève* is un-

loading cargo or stores into a barge alongside while moored within the Old Port of Marseille. The word "père" has been added to Roux's signature because by this time his eldest son, Antoine, Jr., was also actively engaged in ship portraiture.

42. EMPORIUM. "Emporium of Boston Silas S. Bourne Master" [American ship]. Watercolor. 17¼ x 22¼ in. (43.8 x 56.5 cm.). Signed, l.r., "Ant^e^ Roux père, Marseille 1833 = 9." Gift, Charles H. Taylor, 1938. M6410

Emporium was built at Wiscasset, Maine, in 1831-1832. She measured 309 tons, 109′ ½″ length, 25′ extreme breadth, and 12′ 6″ depth of hold. Her owners were Benjamin Sewall of Boston and Jotham Parsons of Wiscasset. The numeral "9" in the date following Roux's signature seems to be part of a numbering system he attempted to maintain from time to time.

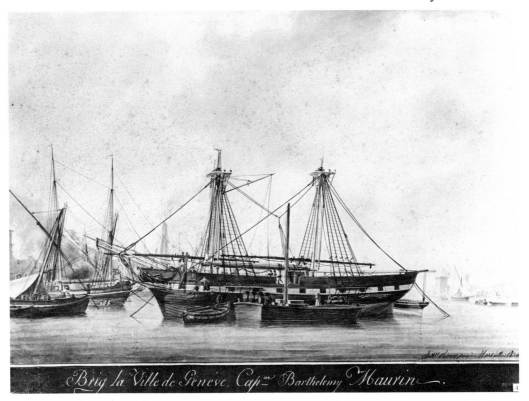

Brig la Ville de Genéve, Cap.ne Barthelemy Maurin

41

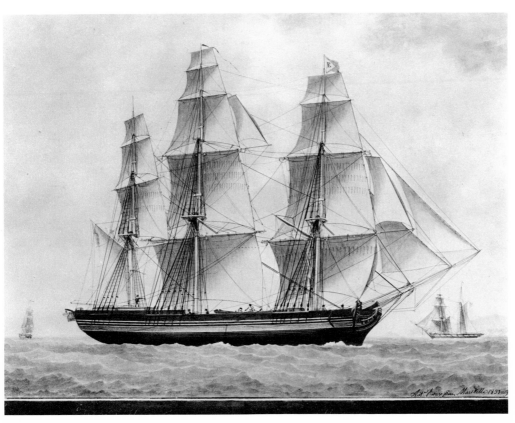

42

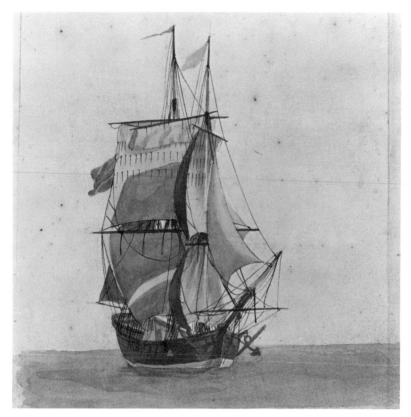

43

44

MISCELLANEOUS

43. Unidentified British Brig. Watercolor. 6¾ x 6¾ in. (17.2 x 17.2 cm.). Unsigned, attributed to Antoine Roux. Pencil sketch on reverse. Gift, Eugene Dow, 1954. M8567

Undoubtedly, this watercolor is a page from one of Antoine Roux's sketchbooks.

44. Marseille, the Old Port. Black and white wash. 9¾ x 14¾ in. (24.8 x 37.5 cm.). Unsigned, attributed to Antoine Roux. Dated, upper left, "1812 Le 7 Mai." On reverse: pencil sketch of a small vessel on the building stocks. Gift, from the Richard Wheatland Collection, 1972. M15178

45. Unidentified Shipping at Sea. Pencil sketch. 8½ x 12 in. (21.6 x 30.5 cm.). Unsigned, attributed to Antoine Roux. Dated, 1817. Gift, from the Richard Wheatland Collection, 1972. Not illustrated. M14877

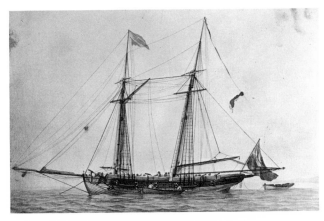

47

48

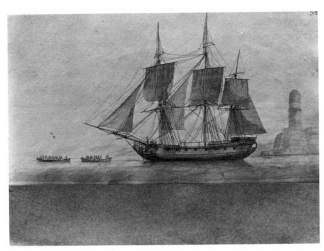

46

SKETCHBOOKS

[NOTE: The numbers which begin each entry are Antoine Roux's own and appear, together with his name and sketchbook date, on the cover of each volume. The count of sketches contained within each, as listed below, reflects the number of pages, not necessarily individual drawings. Frequently, two or more pictures appear on the same page. The predominant medium used on the page has been used to establish the count.]

46. 5. "Carnet d'Etude de Marine Ant^ne Roux 1790." 7 x 12⅜ in. (17.9 x 31.5 cm.). Purchase, 1928. M3359

Summary of contents: 41 watercolors, 5 pencil, 5 wash of local, deep-water, and naval vessels of various countries; harbor views of Marseille and vicinity. Identified: H.M. frigate *Ambuscade*, p. 26.

47. 14. "Carnet d'Etude de Marine Par Ant^e Roux 1801." 9⅜ x 12½ in. (24 x 31.7 cm.). Purchase, 1928. M3359

Summary of contents: 23 watercolors, 5 pencil, 10 wash of merchant and naval vessels, views around Marseille and Cette. Identified: French warships *Le Republicain*, p. 5; *Le Peuple Souverain*, p. 6; *La Sanspareille*, p. 22.

48. 35. "Ӕ aout 1810 [?]." 5 x 9⅝ in. (12.6 x 25.6 cm.). Purchase, 1928. M3254

Summary of contents: 16 watercolors, 14 pencil, 1 wash of local vessels, small craft, shore views, and figures.

49

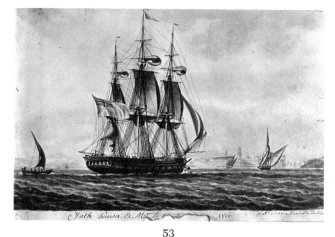

53

50

51

52

49. 37. "Ant^ne Roux 7^bre 1812." 5⅝ x 9¼ in. (14.2 x 23.5 cm.). Purchase, 1928. M3254

Summary of contents: 21 watercolors, 9 pencil, 6 wash of shipping, shore views, figures, and a dog.

50. 23. "Carnet d'Etude de Marine par Ant^ne Roux 1813." 6⅜ x 11¼ in. (16.1 x 28.5 cm.). Purchase, 1928. M3254

Summary of contents: 18 watercolors, 13 pencil, 1 wash of shipping, shore views, and figures.

51. 24. "Carnet, d'Etude d'Apres Nature Par Ant^ne Roux 1813." 6⅛ x 9⅞ in. (15.6 x 25 cm.). Purchase, 1928. M3254

Summary of contents: 15 watercolors, 11 pencil of shipping and figures. Identified: corsaire *La Themis*, p. 11; a naval engagement of April 16, 1814, p. 12.

52. 33. "A^ne Roux 1816." 4¾ x 9½ in. (12.1 x 24 cm.). Purchase, 1928. M3254

Summary of contents: 9 watercolors, 53 pencil, 2 wash of shipping, waterfront scenes, figures. Identified: Neapolitan frigate *La Sirène*, opposite p. 8; Dutch frigate *La Concorde*, p. 10; *L'Indien*, opposite p. 21.

53. []. [No cover inscription; several sketches dated 1816]. 7½ x 10¾ in. (19 x 27.3 cm.). Purchase, 1910. 699.63-R87.1

Summary of contents: 27 watercolors illustrating primarily regional vessel types of the northwestern Mediterranean, each identified by type (chebecs, bombardes, demi-Galères, feluccas, etc.). Identified: British "Yath" *Louisa*, p. 1; *Louisa's* boat, p. 4. This and sketchbook No. 5 are probably the most beautiful examples of Antoine Roux's sketchbooks in the Peabody Museum collection.

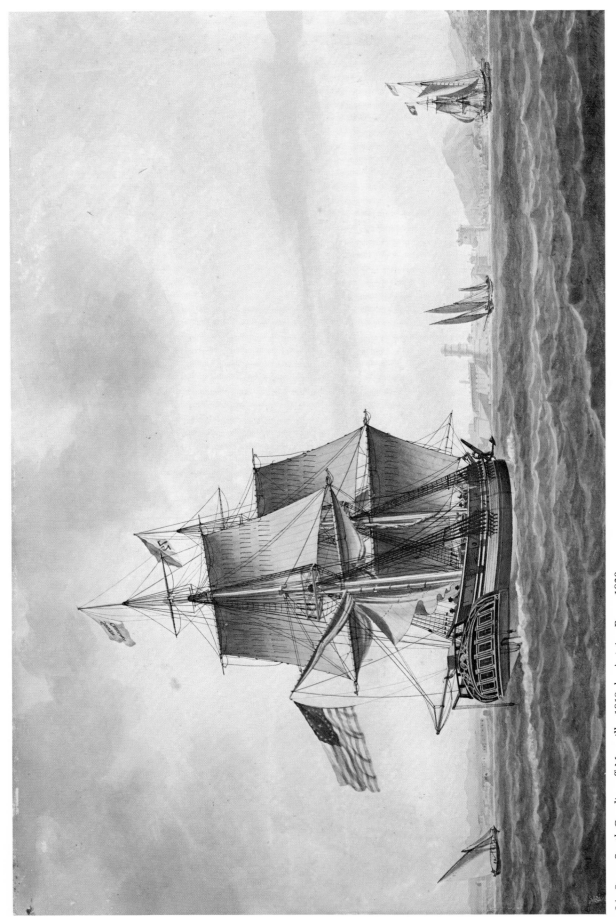

34. Snow *South Carolina* off Marseille, 1819, by Antoine Roux, 1820

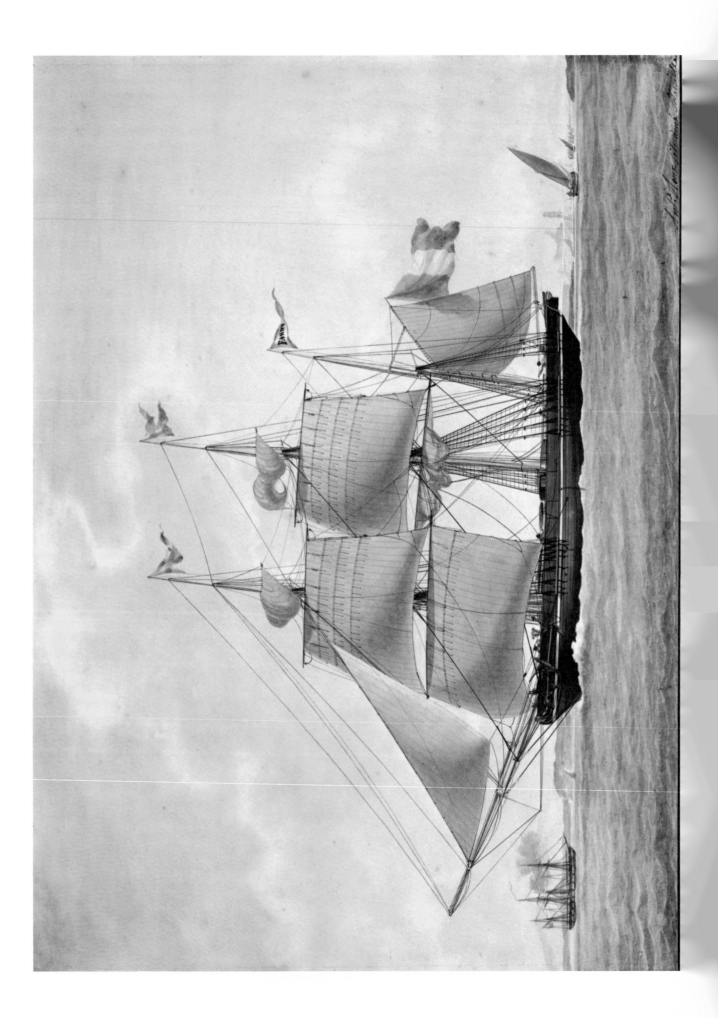

54

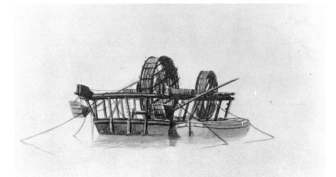

55

56

57

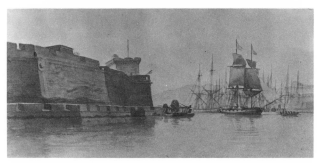

58

59

54. 30. "Æ ✱✱ 1817." 4¾ x 9⅛ in. (12.1 x 23.2 cm.). Purchase, 1928. M3254

Summary of contents: 8 watercolors, 26 pencil, 1 pen and ink, 1 wash of shipping, shore views, and figures. Identified: ship *Alligator,* opposite p. 7; British ship *Tartar,* opposite p. 10; British frigate *Ganymede,* p. 11; frigate *Wasp,* p. 14.

55. 32. "Antⁿᵉ Rxxx 1817." 4½ x 9½ in. (11.5 x 24.1 cm.). Purchase, 1928. M3254

Summary of contents: 13 watercolors, 15 pencil, 7 wash of shipping, waterfront scenes, harbor dredges, and figures.

56. 63. "Antⁿᵉ R✱✱✱ 1819 Mai." 4¼ x 9⅛ in. (10.8 x 23.1 cm.). Purchase, 1928. M3254

Summary of contents: 14 watercolors, 13 pencil, 9 wash of shipping, waterfront and inland views, grottoes, figures, and equipment. Pencil sketch (unidentified) of "Montaudis," the Roux holiday camp, on the inside back cover. Identified: American topsail schooner *Spark,* p. 16.

57. 47. "Aⁿᵀⁿᵉ R. . . 7ᵇʳᵉ 1820." 6¾ x 9¾ in. (17.3 x 24.8 cm.). Purchase, 1928. M3254

Summary of contents: 22 watercolors, 10 pencil, 3 wash of waterfront and inland views, shipping, and figures. Trompe l'oeil of a fly on p. 20 (see verso of this catalogue's title page). Identified: ship *Cinq Frères,* p. 7.

58. 48. "Antⁿᵉ Rˣ 1820." 4¾ x 9⅞ in. (12.2 x 25 cm.). Purchase, 1928. M3254

Summary of contents: 25 watercolors, 8 pencil, 4 wash of shore scenes, shipping, figures, and rock formations.

59. 52. "A.R. 1821 mai." 5⅜ x 11⅜ in. (13.6 x 28.7 cm.). Purchase, 1928. M3254

Summary of contents: 12 watercolors, 8 pencil, 5 wash of shore scenes, interior views, figures, shipping, and shipbuilding. Identified: *Le Jeune Antoine,* p. 16.

60

61

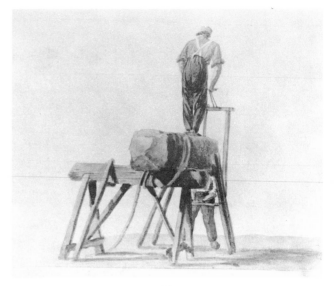

62

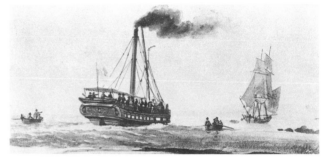

63

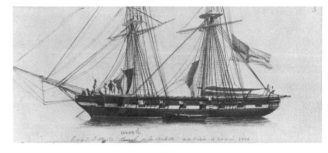

64

65

60. 53. "Ant^e R. .x 1821." 5½ x 11¾ in. (14 x 29.8 cm.). Purchase, 1928. M3254

Summary of contents: 17 watercolors, 4 pencil, 4 wash of shore views, figures, shipping, and shipbuilding.

61. 54. "*Æ* 1821." 4½ x 10½ in. (11.5 x 26.7 cm.). Purchase, 1928. M3254

Summary of contents: 21 watercolors, 4 pencil of shipping, figures, dredges, and shore views. Identified: stern of *Duncan Forbes* of Aberdeen, p. 1; wreckage of *La Therezine*, p. 6; frigate *Laine* (?), Captain Tait, p. 11.

62. 68. "A.R.✳✳ 1822 Oct^bre." 5½ x 11⅛ in. (15 x 28.3 cm.). Purchase, 1928. M3254

Summary of contents: 26 watercolors, 12 pencil, 2 wash of shipping, rocks, shore scenes, figures. Identified: frigate *La Junon*, p. 17.

63. 40. "A.R. 1823 mars." 4½ x 10 in. (11.4 x 25.4 cm.). Purchase, 1928. M3254

Summary of contents: 27 watercolors, 5 pencil, 1 wash of shore views, figures, and shipping, including an unidentified local steamboat. Identified: British ship *Adventure*, opposite p. 17.

64. 51. "A.R. Mars 1824." 4½ x 10 in. (11.5 x 25.5 cm.). Purchase, 1928. M3254

Summary of contents: 28 watercolors, 9 pencil, 2 wash of shipping, shore views, and figures. Identified: H.M. brig *Weasel*, p. 5.

65. 65. "A^E R^x Dec^bre 1826." 4½ x 9⅝ in. (11.5 x 24.5 cm.). Purchase, 1928. M3254

Summary of contents: 16 watercolors, 14 pencil, 7 wash of shipping, shore views, and figures.

MATHIEU-ANTOINE ROUX (1799-1872)

MATHIEU-ANTOINE ROUX was born at Marseille on May 20, 1799, six years after the death of his grandfather Joseph, the first of four children born to Antoine and his wife Rose Elizabeth Gabrielle Catelin.

Like his father before him, daily exposure to business at the hydrographic shop as well as the

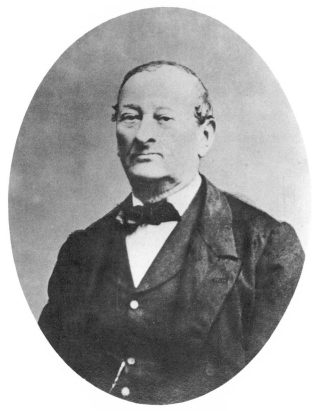

66. Mathieu-Antoine Roux. Peabody Museum photograph collection.

work always in progress on some new ship picture naturally inclined him to follow in the paternal footsteps. Eventually, however, he succeeded to the hydrographic business of an uncle, a short distance from the old shop on the Quai du Port, and carried with him the two papier-mâché figures first used by Joseph.* They became a prominent feature on his trade cards.

Of the three sons, Antoine, Jr. was the least pro-

lific and, in truth, the least talented. His style and draftsmanship certainly resembled his father's and, upon rare occasions when he was unusually inspired, could be confused with the older man's least-accomplished work. What the son seems to have lacked that the others possessed was an instinctive genius for composition, delicacy of touch, and a constantly maturing style. His did not grow, at least not to the same extent as the others, and his technique, even, was apt to be inconsistent.

These are harsh words, but they are not intended to detract from the obvious virtues and interest of his paintings in their own right. As an artist, he was vastly superior to many of the other Mediterranean port painters who worked in the genre. Yet, when mirrored by the greater talents of his father and two younger brothers, his work lacked a spark or spirit which can be sensed if not defined.

During the 1920's, when the members of the now defunct Marine Research Society of Salem were carrying on a vast correspondence with persons in France also interested in the Roux family, an aged gentleman of Marseille, Edouard Gaubert, was prevailed upon to commit his recollections of the Roux sons to paper. The result, entitled "Some Personal Reminiscences," was published in the society's volume *Ships and Shipping*, a book devoted entirely to the Roux family and its marine painting.

Antoine Roux, the younger [Gaubert wrote], was a friend and contemporary of my father. I was twelve years old when I first met him in 1855, having gone with my father to see him for the purpose of getting some ship models that interested me.... Antoine Roux was sixty-one years old at that time.* He was a typical Marseillais, somewhat stout, with a round face and wore neither beard nor mustache. At this period the redingote and tall silk hat were the fashion and it was clad in these that he sat in his shop drawing and painting the portrait of some vessel that had been ordered by her captain or owner. At his age he naturally wore spectacles and these invariably rested on the very end of his nose. Frequently a cigar, held carelessly between

* Antoine, Jr.'s shop was located on the rue de la Loge, a narrow street running parallel to the Quai du Port.

* Gaubert was in error here. In 1855, Roux would have been fifty-six.

his lips, completed the expression of "bonhomie" that was so characteristic of him.

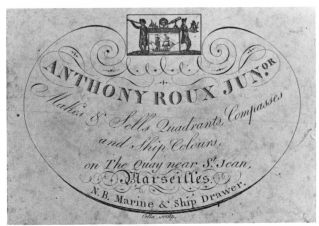

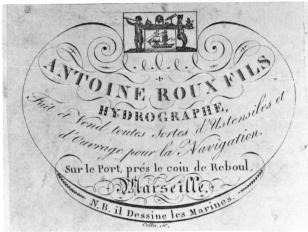

67. Antoine Roux, Jr.'s trade cards, one in English and another in French, illustrate the two figures originally used as signs at his grandfather Joseph's hydrographic shop but later adopted for his own use. Peabody Museum collection.

The shop was unassuming. The entrance was through a double door opening flat against the wall of the building and above it was the sign—ANTeROUX. At the right and left, on each wing of the door, were hung out every day two brackets supporting papier-mache statues representing naval officers of the 18th century each holding a nautical instrument in his hand as shown in the engraving of the sign here reproduced [Antoine's trade card]. This engraving goes back to the time when the shop was first opened and I procured it from one of the grandchildren of our artist. It was used as a label and sometimes is found pasted on the back of the Roux water-colors.

The shop was not large. The entrance was through glass-paned doors. Inside at the right and left were glass showcases containing optical instruments, mariner's compasses, ship lamps, dividers, books, etc., and all sorts of objects relating to navigation.

As one entered the shop there was at the left a wooden school-desk painted black and about a yard in width. It was seated at this desk that I first saw Antoine Roux painting the water-colors that aroused my admiration. He worked, dressed as I have described above, without taking any note of what was going on about him, while his son Tonin Roux sold charts and other articles of his merchandise to the sea captains who frequented the place.*

The shop had windows on all sides. In the middle was a counter on which the various articles were displayed that were sold by Tonin. At the right, between this counter and the entrance door, four to six women were usually at work making signal flags used at sea for communication with passing ships.

When Antoine Roux, Jr. died in his seventy-third year, on January 26, 1872, his son Tonin continued the hydrographic business, but marine paintings were no longer painted in his shop as they had been for well over half a century.

* "Tonin" was François Antoine Roux (1826-1897)—see genealogical table.

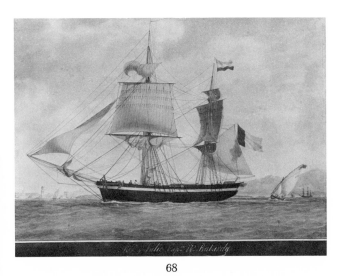

68

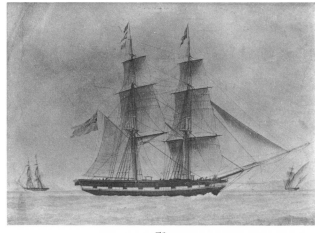

71

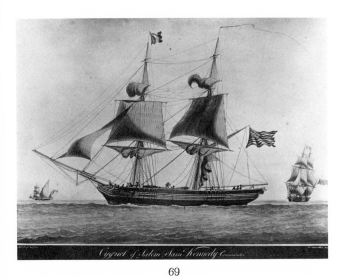

69

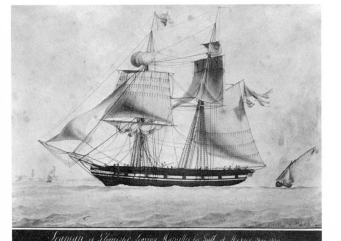

70

68. MNE & JULIE. "Mne & Julie, Capne Ns Rabardy" [French brig]. Watercolor. 17 x 23 in. (43.2 x 58.4 cm.). Signed, l.r., "Ante Roux fils aîné Marseille 1815." Bequest, Miss Rabardy (granddaughter of the captain), 1954. M8341

This, the earliest painting by Antoine Roux, Jr. in the Peabody Museum collection, was painted by him when he was but sixteen years of age. His father's influence is immediately apparent. *Mne & Julie,* her main course, topsail, and topgallant aback, checks her progress as a pilot boat approaches on her starboard quarter.

69. CYGNET. "Cygnet of Salem, Saml Kennedy Commander" [American snow]. Watercolor. 16½ x 22½ in. (41.9 x 54.6 cm.). Signed, l.l., "Anthny Roux the son," and dated, l.r., "at Marseilles 1824." Gift, Dr. Charles Goddard Weld, 1906. M765

Cygnet was built at Salem in 1822 and measured 215 tons, 92' 4" length, 22' 10" extreme breadth, and 11' 5" depth of hold. Here, Roux illustrates her in two positions, an artistic device frequently employed by ship portraitists.

70. SEAMAN. "Seaman of Gloucester, Leaving Marseilles for Gulf of Mexico, May 1825" [American brig]. Watercolor. 17 x 22¾ in. (43.2 x 57.8 cm.). Signed, l.r., "Antny Roux Juner Marseilles—May 1825." Bequest, Professor Charles S. Sargent, 1927. M3169

Seaman was built at Catskill, New York, in 1810. She measured 181 tons, 70' 7" length, 23' 5" extreme breadth, and 11' 7" depth of hold. Elias Davis was master; Winthrop Sargent of Gloucester, Massachusetts, owner.

71. TASWELL (?) [British snow]. Watercolor. 15 x 22 in. (38.1 x 55.9 cm.). Signed, l.r., "Ant Roux fils aîné Marseille 1829." Gift, Dr. Edward D. Lovejoy, 1946. M5874

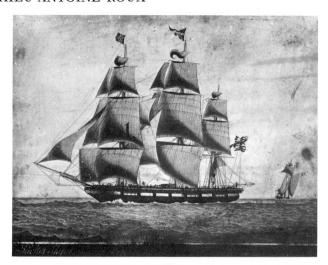

72

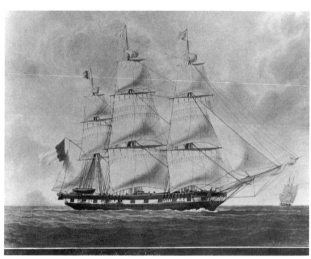

73

72. COMMODORE PERRY. "Packet Ship Commodore Perry F. W. Moores Master 90 hours from Charleston to N. York Aug [] 1th 182[]" [American ship]. Watercolor. 15½ x 22 in. (38 x 55.8 cm.). Unsigned, attributed to Antoine Roux, Jr. Gift, Charles H. Taylor, 1938. M6429

Commodore Perry was built at New York in 1816. She measured 262 tons, 92' length, 25' 6" extreme breadth, and 12' 9" depth of hold. She was one of the pioneer packets of the Charleston Ship Line, serving for five years between 1822 and 1827 on the New York-Charleston run and averaging 6.8 days on her passages. The "A.1." on her fore-course indicates (for the attraction of passengers) her Lloyds insurance rating.

73. JEUNE IRMISSE. "Jeune Irmisse, Capⁿᵉ C. Ventre, arᵗᵉᵘʳ Tʰ Pellegrin Marseille" [French ship]. Watercolor. 17½ x 22¾ in. (44.4 x 57.8 cm.). Signed, l.r., "Antᵉ Roux fils aîné Marseille 1832." Gift, Leonard E. Opdycke, 1977. M17075

The word "arᵗᵉᵘʳ" is "armateur" or "builder." Thus, this painting was probably done for *Jeune Irmisse*'s builder, Thomas Pellegrin. It would be interesting to know if he were a relative of Honoré Pellegrin (circa 1800-circa 1870), another ship portraitist of Marseille, whose work is frequently confused with that of members of the Roux family.

74. FANNY. "Fanny Capⁿᵉ Louis Cardonnet Juin 1832" [French bark]. Watercolor. 17¼ x 22¼ in. (43.8 x 56.5 cm.). Signed, l.r., "Ante Roux fils aîné Marseille." Purchase, 1931. M3756

See color plate facing page 31.

Fanny was built at Marseille in 1832. Antoine Roux's trade card in French (illustrated earlier) is affixed to the back of this picture.

URSULE JOSÉPHINE ROUX (1801– ?)

BORN in 1801 and christened Ursule Joséphine, virtually nothing is known about the Roux sister. She seldom painted, Edouard Gaubert recollected in 1924, "but when she did it was in a pleasing manner. I have seen but three water-colors done by her and two of them I possess. They are small. One is entitled 'L'Entrée du Port de Marseille' and the other 'La Calanque de l'Ourse.'"

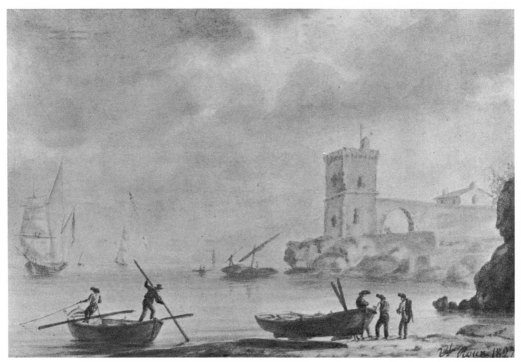

75

75. View of Marseille Harbor. Watercolor. 7¼ x 9¾ in. (18.4 x 24.7 cm.). Signed, l.r., "Ule Roux 1827." Purchase, 1931. M3714

Very few of Ursule's watercolors are known, but judging from the Peabody Museum's solitary example of her work she was proficient and an artist in her own right, having inherited from her father and brothers the disciplines and fascinations of a watercolorist.

FRANÇOIS JOSEPH FRÉDÉRIC ROUX (1805–1870)

THE third child and second son of Antoine Senior, Frédéric Roux was born in 1805, also at Marseille. To confuse matters, genealogically, his baptismal name seems to have been François Joseph Frédéric.

By 1822, at the age of seventeen, he was already painting for profit, having developed a style that would have been the envy of many an older practitioner. The copy of his father's watercolor of H.M.S. *Proserpine*, clearly signed and dated that year, is evidence of his precocious talent. One suspects there may have been friction with his brother Antoine, who was six years his elder but whose abilities were obviously inferior. In view of the fact that Frédéric ultimately left Marseille and that Antoine, Jr. succeeded to the hydrographic business of an uncle rather than to that of his own father, the pos-

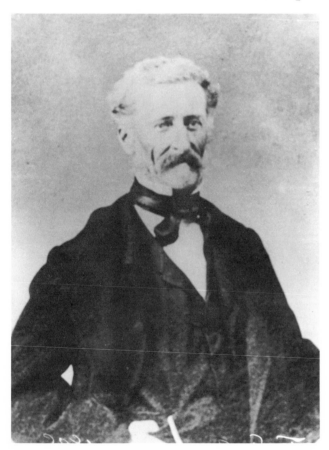

76. François Joseph Frédéric Roux. Peabody Museum photograph collection.

sibility is even more likely. Certainly Antoine, the father, must have taken a special interest in Frédéric; otherwise he could not have achieved what he did at so early an age.

The Peabody Museum's collection of originals by Frédéric, as well as several score photographs of others owned elsewhere, indicates that he continued working at Marseille until the year 1827.

"On a voyage which Carle Vernet and his son Horace made to Marseilles," recounted Louis Brès in 1883, "the two artists stopped at the shop of the painter-hydrographer, attracted perhaps by some portrait of a ship recently displayed in the show window and won over no doubt by that ardent admiration which Antoine [the father] professed for the works of Joseph Vernet [Carle's and Horace's father and grandfather, respectively]. The beginnings, full of promise of young Frédéric, arrested their attention and they persuaded his father to send him to Paris, promising him aid and protection."

The father agreed, Frédéric accepted, and soon he was off to Paris where he entered the Vernet studio.

Shortly after his arrival there, he attracted the notice of Admiral Jean-Baptiste Philibert Willaumez (1761-1845) who commissioned him to prepare a series of forty watercolors illustrating the vessels in which he had served and others which the admiral's studies of naval technology had enabled him to improve. The major part of the series was completed during the years 1827 and 1828 and now is at the Musée de la Marine of Paris. Yet another series, consisting of twenty-three watercolors dedicated to the Duc d'Orléans, son of Louis Philippe, was completed in 1831.

Frédéric remained in Paris for a number of years before removing to Havre on the Channel coast, evidently about 1835, there to set up shop as a hydrographer and as a "painter of marines." It is tempting to speculate that his painting of 1834, here entitled "Fleet Maneuvers," was executed as something of a final examination at the atelier Vernet.

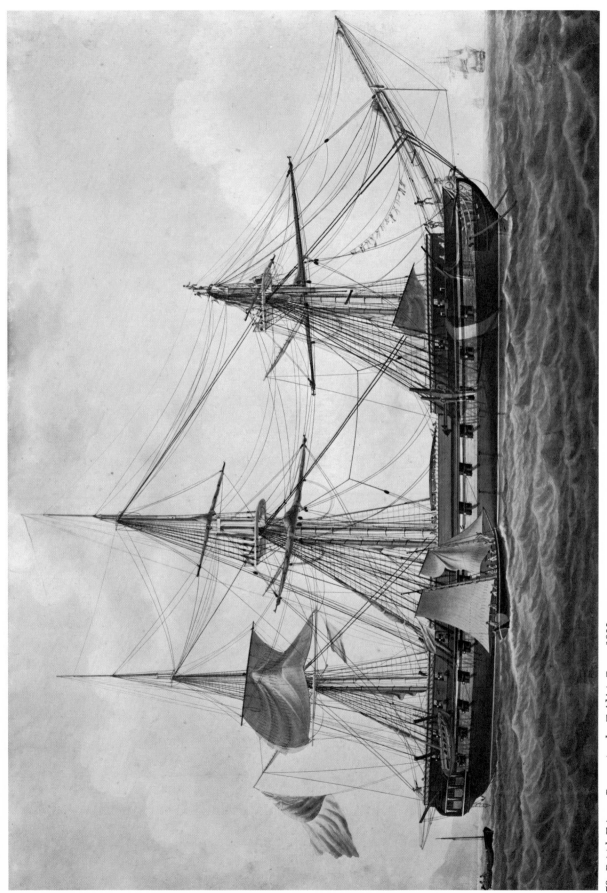

78. British Frigate *Proserpine*, by Frédéric Roux, 1822

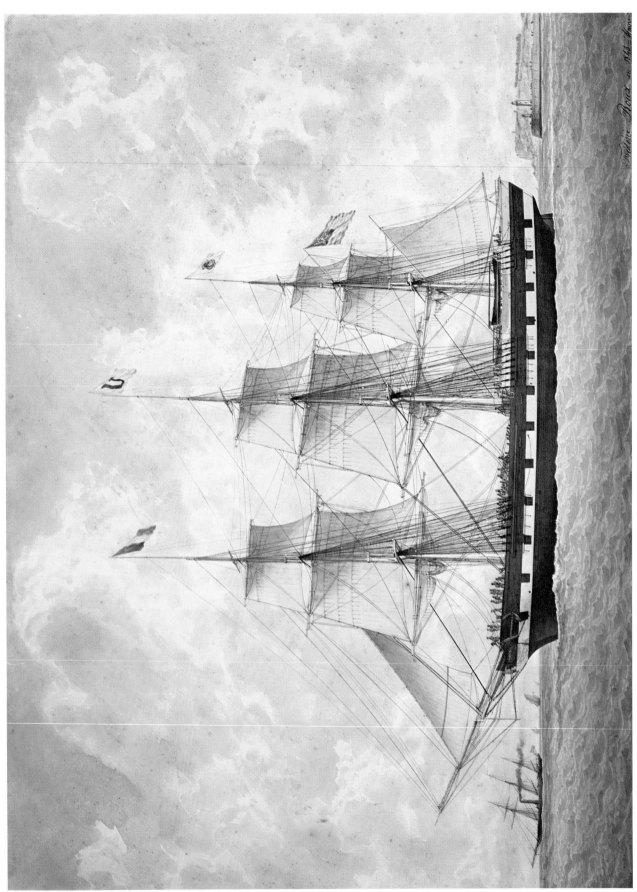

90. Ship *Havre*, by Frédéric Roux, 1845

"He would certainly have realized a fortune here," Brès wrote of his settlement at Havre, "for he became in a very short time the recognized painter of all the American Captains who were astonished by his prodigious facility. But our Provençal had imbibed in the studio of Horace Vernet—in that studio where fencing was practiced, the guitar played, where champagne corks popped, where time was passed so gaily—he had imbibed, we repeat, other things than the practice of his art; he had acquired here the taste for a life of adventure and of pleasure. Hence his numerous journeys to Russia, Norway and other places; hence that existence of feverish work and of joyous distractions, amid which the artist scattered his talent.

"He returned on two or three occasions to Marseilles to see again the neighborhood where he was born and the companions of his childhood," Louis Brès wrote. "It pleased him on such occasions to discourse in Provençal as in the old days, asserting that it was a real treat for him to hear the sonorous idioms of the fishermen of Saint-Jean. His was a heart of gold, a truly artistic nature. It is related that the Prince Napoléon had given him a commission to paint his yacht, the 'Jerome-Napoléon.' The work completed, the Prince was charmed with it and ordered a copy of it to send to his father-in-law, the King of Italy. But the agent of the Prince sought to haggle. 'Say to his Highness,' replied the artist, 'that he shall have the copy at the same price as the original. I could not take off a centime. If it is found to be too dear, I will make a present of it myself to the King of Italy.' And he would have done just as he said if the Prince had not given the commission."

It is always of interest to know just how much the Roux clients paid for one of their pictures. Unfortunately, we rarely find out, yet recently a watercolor by Frédéric appeared on the market which had his bill attached to the back of it. The painting was of an American ship entering the port of Havre in 1856. It cost, originally, including a packing case to ship it home, 126 francs! It is unnecessary to comment on what the modern dealer thought he could get for it.

Frédéric's style underwent numerous changes. While still working at Marseille, under the tutelage of his father, it naturally reflected what Antoine

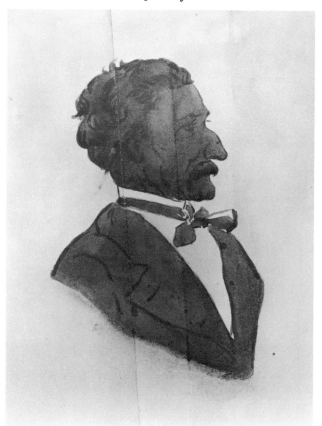

77. Wash sketch of François Joseph Frédéric Roux, made in 1863 by an unidentified artist, in the Peabody Museum collection (M3144).

was able to teach him. Their techniques were then very similar, as might be expected. Antoine seems to have taught his sons by requiring them to copy as exactly as possible examples of his own work still remaining in the shop. Some of it was fairly old, so it is not surprising that Frédéric's endeavors, including *ex voto* work, were highly reminiscent of Antoine's youthful work—stylized, high-crested waves; Fort St. Jean in the background; vessels backing their topsails while awaiting the pilot; full broadside views rather than looser, more dramatic compositions.

After the Paris experience, Frédéric became infinitely more adaptable. The majority of his commissioned ship portraits were still ground out by rote—broadside views of vessels entering and leaving Havre, the water delineated in a mathematical, predetermined fashion—but he was no longer bound by familial tradition. When circumstances demanded it he could, and was able, to do as he pleased.

39

Just how much of his work was proliferated by the engraver's plate or the lithographer's stone for the mass market of the day has not been determined, but several contemporary lithographs of his paintings are in the Peabody Museum collection and are included in the accompanying listings. The earliest seen by the author, although only by means of a photograph, is of an American frigate at anchor, her courses and topsails aback. "Dessiné par F. Roux à Marseille" and "Gravé Par C. F. Barallier

1824," the lithograph was published "A Paris chez BULLA rue St Jacques No 38 et à Marseille chez Ruspini." Ruspini was a print seller located just a few doors down from the Roux shop. Undoubtedly it was he who put him up to it.

Except for his various foreign trips and the occasional visit to his old stamping grounds at Marseille, Frédéric Roux lived out the remainder of his life at Havre where he died in January, 1870.

78. PROSERPINE [British frigate]. Watercolor. 22⅜ x 35 in. (61.9 x 89 cm.). Signed, l.r., "Fred Roux 1822." Gift, from the Richard Wheatland Collection, 1977. M17137

See color plate facing page 38.

Although this painting is not identified, the watercolor is unquestionably a copy by Frédéric of a known painting by Antoine (the father) of H.M.S. *Proserpine*. It is not an exact copy, but it nevertheless attests to the son's skills not only as a copyist but as a masterful technician in his own right. If the date is correct, he would have been only seventeen years of age at the time.

79. CAMBRIAN. "Cambrian" [American snow]. Watercolor. 16¾ x 22¾ in. (42.6 x 57.8 cm.). Signed, l.r., "frederic Roux à Marseille 1826." Gift, Mrs. Richard Wheatland, 1948. M6197

Cambrian was built at Salem in 1818 and measured 196 tons, 86′ 4″ length, 22′ 8″ extreme breadth, and 11′ 4″ depth of hold. Owned by Joseph Peabody, the ship was portrayed on either the eighth or ninth of her sixteen voyages out of Salem when she traded in India, the Mediterranean, Cuba, and South America.

80. CHARLEMAGNE. "Charlemagne, Captn Richardson" [American ship]. Watercolor. 16½ x 22¼ in. (41.9 x 56.5 cm.). Signed, l.r., "frederic Roux à Paris en 1828." Gift, Mrs. Kate S. Richardson, 1916. M2140

Charlemagne was built by Bergh at New York in 1828. She measured 442 tons, 124′ length, 28′ extreme breadth, and 14′ depth of hold. In her ten years' service on the New York-Havre run with the Havre Second and Old Lines, she averaged forty-one days on the westward crossings with a record of a twenty-three-day passage to New York.

Cambrian.

79

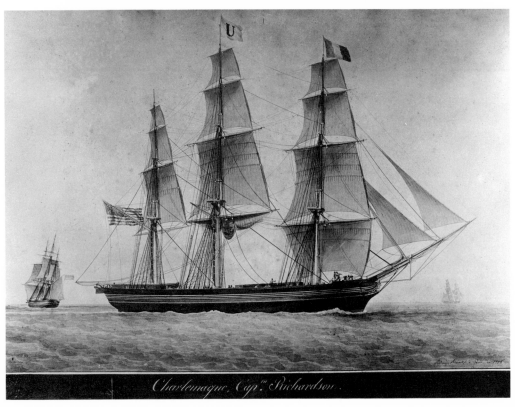

Charlemagne, Cap.ⁿ Richardson.

80

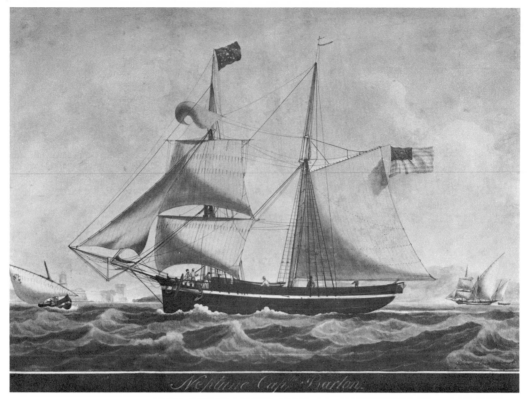

81

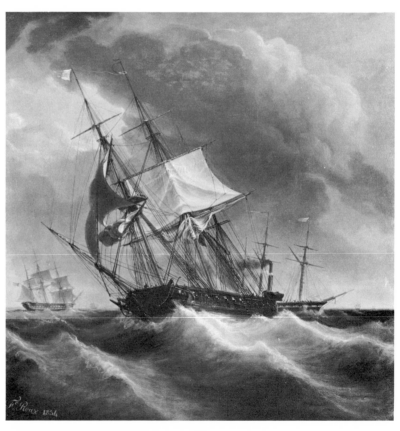

82

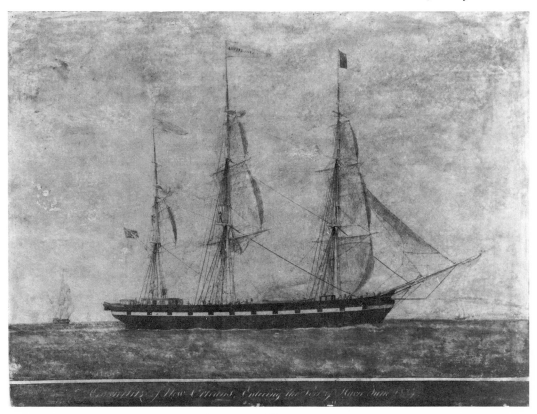

83

81. NEPTUNE. "Neptune Cap^tn Barton" [American hermaphrodite brig]. Watercolor. 16½ x 22¾ in. (41.9 x 57.8 cm.). Signed, l.r., "frederic Roux à Marseille." Undated. Gift, from the Richard Wheatland Collection, 1957. M9156

Neptune was built at Duxbury, Massachusetts, in 1829 where she was also owned. She measured 197 tons, 90′ 2″ length, 22′ extreme breadth, and 11′ depth of hold, an excellent example of a very small vessel engaged in transatlantic trade.

82. Fleet Maneuvers. Oil. 31½ x 31¼ in. (80 x 79.4 cm.). Signed, l.l., "F^c Roux 1834 1834." Purchase, 1968. M13378

The remarkable painting is one of three known oils by Frédéric Roux. The headsails pull as the sun strikes the backed, double-reefed maintopsail, a dramatic painting of great power.

31. Brig Entering Harbor.

Previous mention of this watercolor has been made under Ange-Joseph Antoine Roux. Signed and dated "Ant^ony Roux 1818," the

signature and date are forgeries. The picture more properly should be attributed to Frédéric and should postdate the year 1835.

83. AUSTERLITZ. "Austerlitz of New-Orleans, Entering the Port of Havre June [remainder illegible]" [American ship]. Watercolor. 17¼ x 23½ in. (43.8 x 59.7 cm.). Signed, l.r., "Frederic Roux [illegible] 1837." Inscription on reverse: "Frédéric Roux, hydrographe & peintre de Marine petit quai Notre-Dame N° 13 au Havre Juillet 1837." Gift, Robert J. Clark, 1960. M10568

Austerlitz was built at Medford, Massachusetts, in 1833. She measured 415 tons, 126′ 2″ length, 26′ 6″ extreme breadth, and 13′ 3″ depth of hold. She was owned by William Hammond (who also was the captain) of Marblehead, Massachusetts; Eliazer E. Bradshaw of New York; and Frank Perret & Gally of New Orleans. The ship was disabled in a typhoon and was abandoned at sea, sinking, on December 26, 1850.

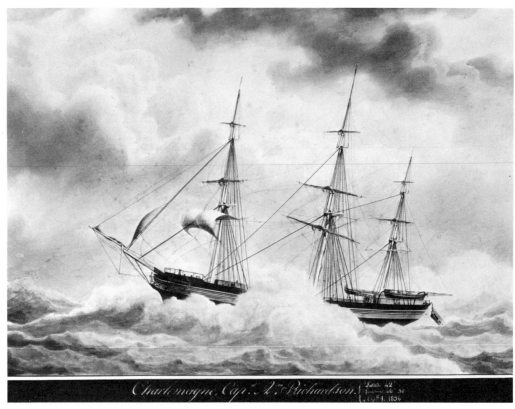

84

84. CHARLEMAGNE. "Charlemagne, Capnt Ason Richardson Latitude 42° Longitude 46°30 Apll 1. 1836" [American ship]. Watercolor. 16½ x 22 in. (41.9 x 55.8 cm.). Signed, l.r., "frédéric Roux [remainder illegible]." Inscription on reverse (now demounted): "Frédéric Roux hydrographe et peintre de Marine petit quai Notre Dame N° 13 au Havre en 1838." Gift, Mrs. Kate S. Richardson, 1916. M2142

Ten years before, during her maiden voyage, Frédéric Roux had painted another portrait of this New York-Havre packet. Note the addition of quarter boats on davits since the painting of 1828.

85. CHARLEMAGNE. "Charlemagne, Captn A. Richardson Lat. 40° Long. 68°30′ January 28th 1838" [American ship]. Watercolor. 16¼ x 22 in. (41.2 x 55.9 cm.). Signed, l.r., "frédéric Roux au Havre 18[38]." Inscription on reverse: "Frédéric Roux, hydrographe Peintre de Marine petit quai Notre Dame N° 13 au Havre en Juillet 1838." Gift, Mrs. Kate S. Richardson, 1916. M2141

A companion to the previous picture, *Charlemagne* is now in a perilous situation: she is partially dismasted, her remaining sails are blowing out, and she is losing her boats.

86. EBRO. "Ebro, Captn Lawson Watts, Leaving the Port of Havre. (1838)" [American ship]. Watercolor. 16½ x 23 in. (41.9 x 58.4 cm.). Signed, l.r., "frédéric Roux au Havre 1838." Inscriptions on reverse: (1) "Frederic Roux hydrographe; peintre de Marines, petit Quai Notre Dame 13—Havre 28 avril 1838" and (2) "L.L. Watts. Master of Ship Ebro. of Hallowell, Maine April 28th 1838. Owned By Saml Watts Sen. B.C. Bailey A. White L.L. Watts Was four [former] Master Feb. 18th 1836. of Ship Lotus." Purchase, 1963. M11651

Ebro was built at Topsham, Maine, by Alfred White (who also owned her) in 1837. Hailing from Hallowell, Maine, she measured 350 tons, 114′ 2″ length, 25′ 11½″ extreme breadth, and 12′ 11¾″ depth of hold.

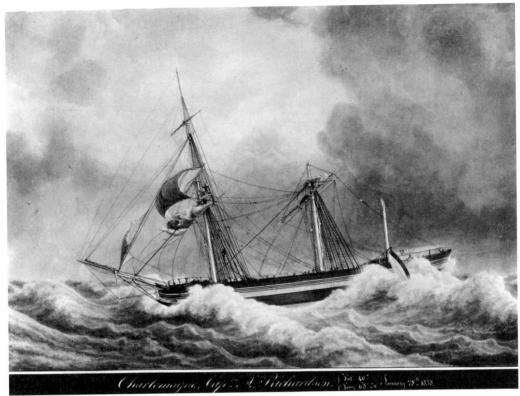

Charlemagne, Capt. J. Richardson. {Lat. 40° Long. 68° 30' January 28th 1838.

85

Ebro, Capt. Jasson Watts. leaving the Port of Havre. (1838.)

86

87

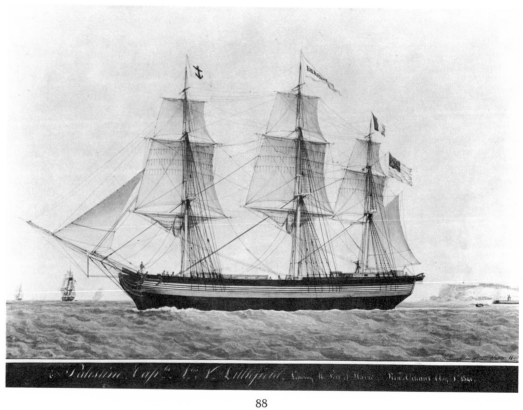

88

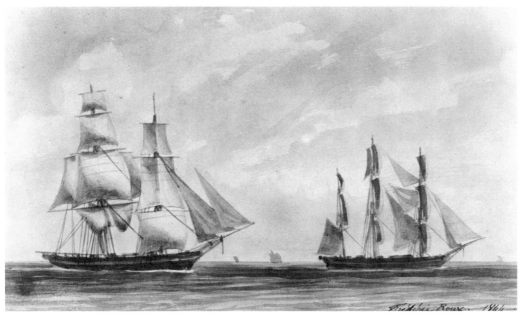

89

87. NAPOLEON. "Napoleon, Cap^ne N^las Rabardy" [French bark]. Watercolor. 16½ x 23 in. (41.9 x 58.4 cm.). Signed, l.r., "frédéric Roux au Havre 1838." Inscription on reverse: "Frédéric Roux hydrographe & Peintre de Marine petit Quai Notre Dame 13 au Havre en 1838." Gift, Miss Rabardy (granddaughter of the captain), 1954.　　M8340

Napoleon, 228 tons, was built at Honfleur in 1833 and was owned in Havre by Lecomte & Rabardy.

88. PALESTINE. "Palestine, Cap^tn A^tus V. Little-field. Leaving the Port of Havre for New-Orleans Aug^t 1^st 1840" [American ship]. Watercolor. 16 x 22½ in. (40.6 x 57.2 cm.). Signed, l.r., "Frederic

Roux, au Havre 1840." Inscription on reverse: "Frédéric Roux, hydrographe & Peintre de Marine petit Quai Notre Dame N° 13 au Havre en Juillet 1840." Gift, Charles H. Taylor, 1938.　　M6414

Palestine was owned and built by George F. Patten of Bath, Maine, in 1833. She measured 470 tons, 127′ length, 28′ 6″ extreme breadth, and 14′ 3″ depth of hold.

89. Unidentified Brig and Ship. Watercolor. 4¼ x 7½ in. (10.8 x 19.1 cm.). Signed, l.r., "Frédéric Roux 1844." Gift, from the Richard Wheatland Collection, 1976.　　M16525

This is probably a leaf from a sketchbook, many of which have been broken up by dealers and sold by the individual sheet.

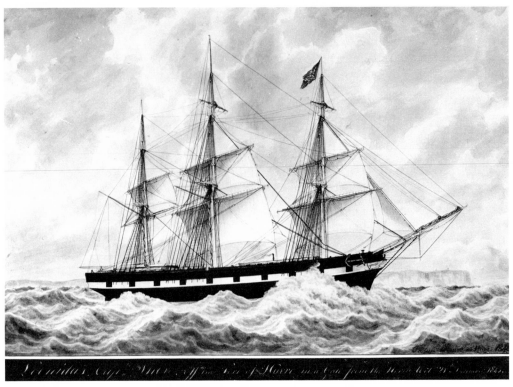

91

90. HAVRE. "Havre, Cap^tn A.C. Ainsworth" [American ship]. Watercolor. 25¼ x 31½ in. (64.1 x 80 cm.). Signed, l.r., "Frédéric Roux in 1845—Havre." Inscription on reverse: "Frédéric Roux hydrographe & Peintre de Marine au Havre en Mai 1845." Gift, Leonard E. Opdycke, 1977. M17077 See color plate facing page 39.

Havre (actually *Havre II*) was built at New York by William H. Webb in 1845 and was one of the New York-Havre packets of the Havre Old Line in which she served from 1845 to 1863 when she was sold Norwegian. Her average passage westbound was thirty-four days, but she once made it in twenty. The ship measured 870 tons, 158' length, 34' extreme breadth, and 20' depth of hold.

91. LEONIDAS. "Leonidas, Cap^tn Snow. off the Port of Hâvre in a Gale from the North-Wet [sic] 21^st December 1845" [American ship]. Watercolor. 15¾ x 22½ in. (40 x 57.1 cm.). Signed, l.r., "Frederic Roux au Havre 1846." Inscription on reverse:

"Frédéric Roux hydrographe & peintre de Marine au Havre en Janvier 1846." Gift, from the Richard Wheatland Collection, 1967. M12845

Although there were several vessels of the name, this *Leonidas* is thought to have been the one built at Scituate, Massachusetts, in 1826. She measured 231 tons, 92' 5½" length, 23' 8½" extreme breadth, and 11' 10¼" depth of hold. For a time, at the end of the 1830's, she was owned in Salem, but in the 1840's was sold to New Bedford owners and became a whaler. She was one of the Stone Fleet sunk at Charleston, South Carolina, in 1861.

92. SOLON. "Solon, Captain George Bucknam. Receiving Pilot off Hâvre 29^th May 1847" [American ship]. Watercolor. 16¼ x 22¾ in. (41.3 x 57.8 cm.). Signed, l.r., "Frédéric Roux au Havre 1847." Gift, Francis B. Lothrop, 1958. M9778

Solon was built at Kittery, Maine, by Samuel Badger in 1834. A vessel of 540 tons, she was owned by Samuel Pray, William Jones, Jr., and Samuel Badger of Kittery, Maine, and Portsmouth, New Hampshire.

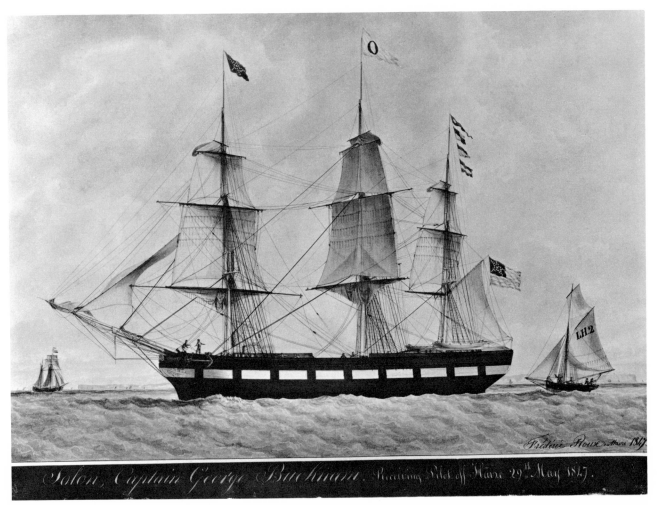

92

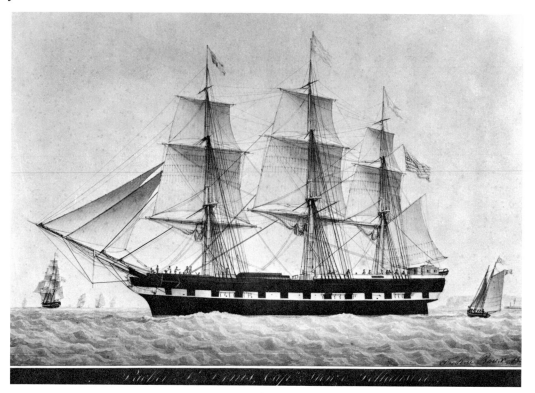

93

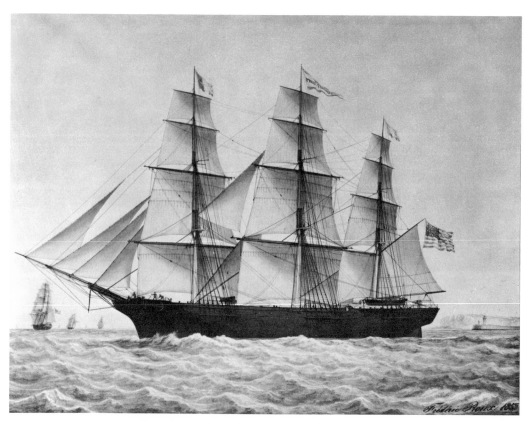

94

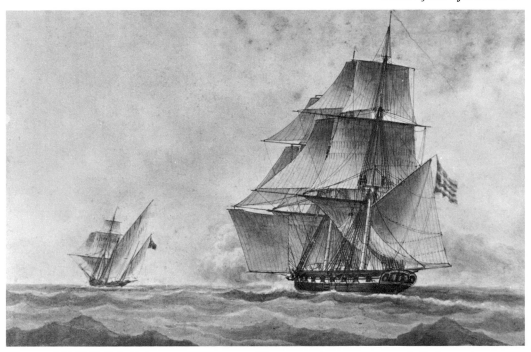

95

93. ST. DENIS. "Packet St Denis, Capⁿ Alonzo Follansbee" [American ship]. Watercolor. 16 x 22¾ in. (40.6 x 57.8 cm.). Signed, l.r., "Frédéric Roux, 1852." Bequest, Horace Follansbee, 1955. M8796

St. Denis was built at New York by Westervelt & Mackey for the New York-Havre Second Line in which she served from 1848 to 1856 as a packet. Her record westbound passage was twenty-five days; her average time, thirty-five. She sank in a gale en route from New York to Havre, January 6, 1856, about 180 miles east of Sandy Hook, New Jersey. Thirty-five of the forty-seven persons on board were lost. The ship measured 959 tons, 161′ length, 36′ extreme breadth, and 21′ depth of hold.

94. PRESIDENT FILLMORE [American ship]. Watercolor. 24 x 31¾ in. (61 x 80.6 cm.). Signed, l.r., "Frédéric Roux 1853." Gift, Charles H. Taylor, 1936. M4232

President Fillmore, a ship of 872 tons, was built at Camden, Maine, in 1852.

95. Greek Frigate in Chase. Watercolor. 8 x 12½ in. (20.3 x 31.7 cm.). Signed, l.r., "Fᶜ Roux 1859." Gift, William A. Robinson, 1959. M6139

Probably originally part of a Frédéric Roux sketchbook.

96

96. Vessel Lying Against a Quay. Watercolor. 7⅞ x 11¾ in. (20 x 29.9 cm.). Unsigned, attributed to Frédéric Roux. Dated, l.l., "le 13 Février 1862." Purchase, 1972. M15278A

This sketch, as well as the next, unmistakably by Frédéric, was inserted into a sketchbook at first believed to be by him but now reattributed to his brother François.

97. "(Tiboulers.) Roche appellée les dents de Crine, attenant à l'Ile de Pomègue, près de Marseille." Watercolor. 7⅞ x 11¾ in. (20 x 29.9 cm.). Signed, l.r., "Fᶜ Roux 1862." Purchase, 1972. M15278B

This, like the previous entry, was an insertion into a sketchbook initially thought to be by Frédéric but subsequently reattributed to his younger brother François.

98. Unidentified French Steamer. Watercolor. 9 x 20 in. (23 x 51.8 cm.). Signed, l.r., "F Roux," and at l.l., "Dessiné le 29 Octobre 1862 10ʰ matin leger vent ouest." At center bottom: "Capⁿᵉ Satrice[?] Dumoyet." Pencil sketches of details in upper left corner. Gift, Stephen Wheatland, 1961. M11025

A rough sketch, this is presumably a page from one of Frédéric Roux's sketchbooks.

99. TAFFARETTE [French bark]. Watercolor. 13½ x 19½ in. (34.3 x 49.5 cm.). Inscribed, l.l., "Voyage en Chine 1859, 1860, et 1861." Signed, l.r., "Frédéric Roux, en mai 1863." Purchase, 1959. M10330 See color plate facing page 54.

Taffarette, 476 tons, was built at Hamburg, Germany, in 1853. She was owned at Havre by De Rothschild Frères.

(Tiboulen.) Roche appelée les dents de Crine, attenant à l'Ile de Pomègue, près de Marseille.

97

98

53

100

101

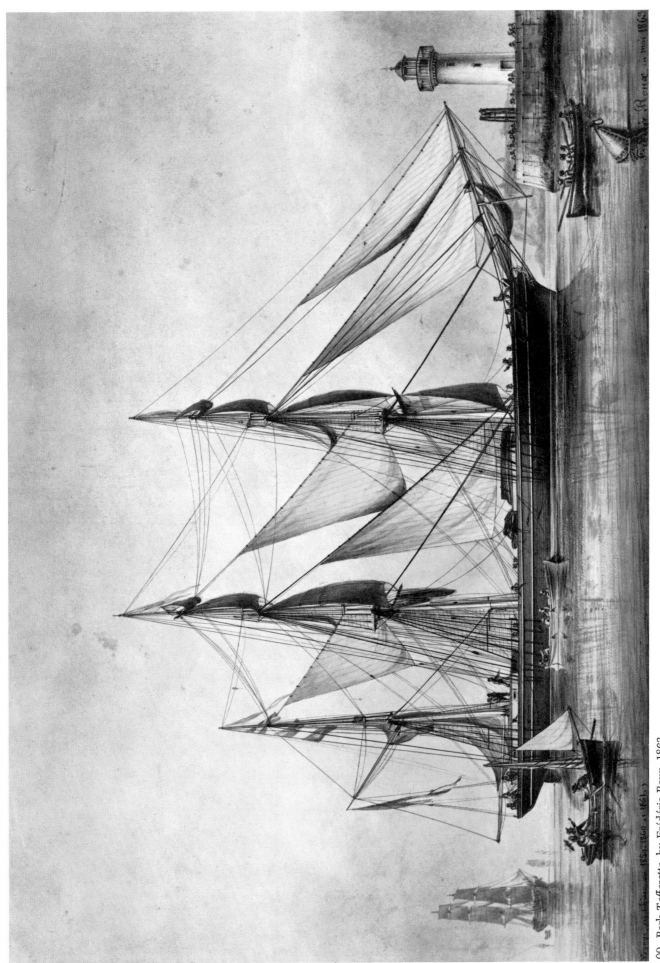

99. Bark *Taffarette*, by Frédéric Roux, 1863

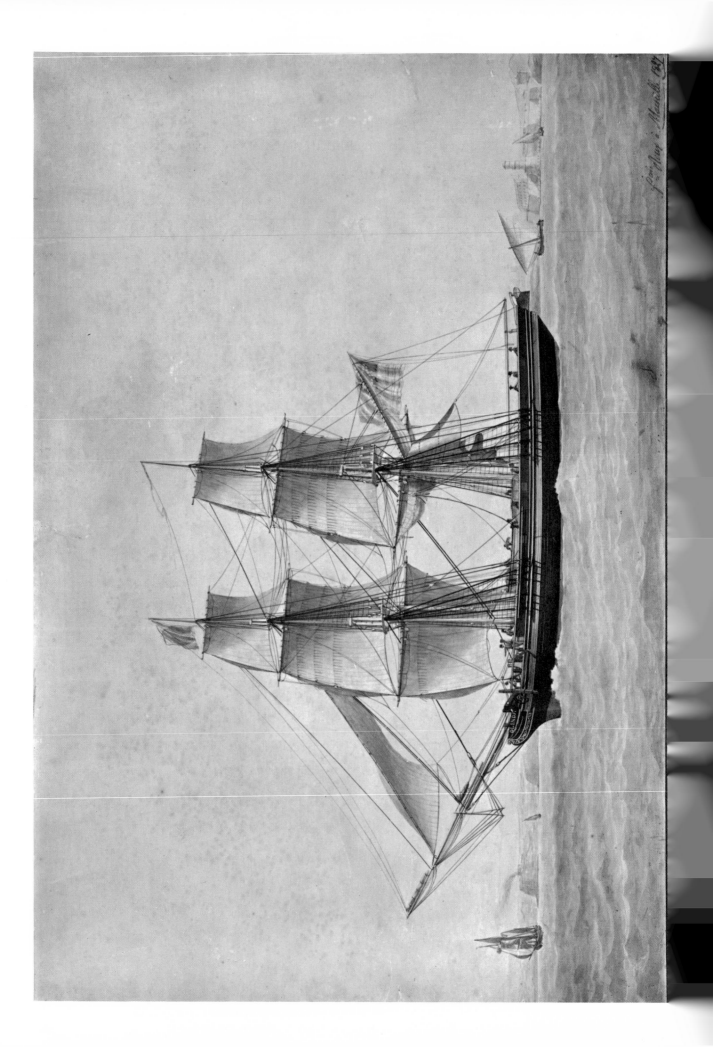

100. Unidentified French Frigate. Watercolor. 24 x 34⅞ in. (61 x 88.6 cm.). Unsigned, attributed to Frédéric Roux. Inscription on reverse: "Achêté le 20 Mars 1866." Gift, from the Richard Wheatland Collection, 1977. M17136

Like the watercolor of *Proserpine* by Frédéric Roux, illustrated earlier, this exquisite picture is probably another of the copies made by Frédéric from one of his father's originals.

101. Unidentified brig. Watercolor and pencil. 16¼ x 22¾ in. (41.3 x 57.8 cm.). Unsigned. Gift, Francis B. Lothrop, 1958. M10101

This unfinished sketch was discovered mounted on the back of the ship *Solon* watercolor during the process of restoration. It illustrates the Roux manner of painting—shapes sketched in lightly with pencil, followed by a watercolor wash over the sky, leading to the additional watercolor and pen-and-ink work which resulted in the finished picture.

SKETCHBOOK DRAWINGS

[NOTE: The following seventeen sketches evidently were once a part of one or more of Frédéric Roux's sketchbooks. All are in pencil; a few have highlights pricked out in color. The collection was purchased by the Peabody Museum in 1937.]

102. *L'Aglaé* [French bark]. Built at Bordeaux, 1846, 282 tons. 8½ x 10 in. (21.6 x 25.4 cm.). M5015

103. *Arkansas* [American ship]. Built at Bath, Maine, 1845, 399 tons. 8½ x 10 in. (21.6 x 25.4 cm.). M4670

104. *Clinton* [American ship]. Built at Bath, Maine, 1840, 350 tons. 7½ x 9¾ in. (19.1 x 24.7 cm.). M4671

105. *Martley Castle* [British ship]. 381 tons, signed, l.l., "F. Roux." 7⅝ x 9⅝ in. (19.3 x 24.5 cm.). M4672

103

104

102

105

106

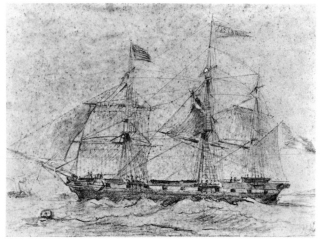

109

107

106. *Nestor* [American ship]. Built at Portsmouth, New Hampshire, 1831, 396 tons. 8⅜ x 9¾ in. (21.2 x 24.7 cm.). M4669

107. *Oceana* [Norwegian ship]. Built at Arendal, Norway, 1846, 445 tons. 8¼ x 9⅝ in. (21 x 24.5 cm.). M5014

108. *Orlando* [American ship]. Built at Newbury, Massachusetts, 1856, 436 tons, signed, l.r., "Le Havre FR." 8⅜ x 9¾ in. (21.2 x 24.7 cm.). M5017

109. *Oscar* [French ship]. Hailing from Bordeaux, 400 tons. 7½ x 9¾ in. (19.1 x 24.7 cm.). M5018

110. *Le Requin* [French bark]. Hailing from Bordeaux. 8⅜ x 9⅝ in. (21.3 x 24.5 cm.). M5016

108

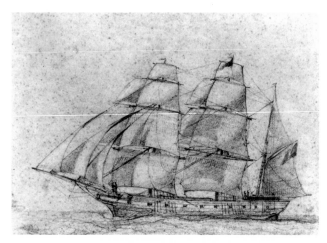

110

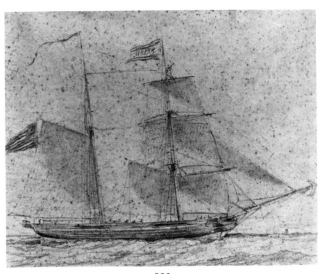

111

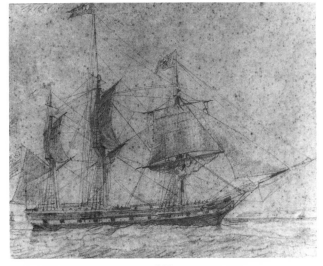

113

111. *Selim* [American hermaphrodite brig]. 197 tons. 8⅜ x 9¾ in. (21.3 x 24.8 cm.). M5220

112. *Speedwell* [American hermaphrodite brig]. Built at Cohasset, Massachusetts, 1843, 104 tons. 8½ x 9¾ in. (21.6 x 24.7 cm.). M4673

113. *Talma* [American ship]. Built at New York, 1825, 391 tons. 8½ x 9¾ in. (21.6 x 24.7 cm.). M4668

114. *Victoria* [Norwegian brig]. Built at Arendal, Norway, 1847, 408 tons. 8½ x 9¾ in. (21.6 x 24.7 cm.). M5019

115. *William Woolley* [British brig]. Built at Poole, 1839, 198 tons. 8¼ x 9¾ in. (21 x 24.7 cm.). M5221

114

112

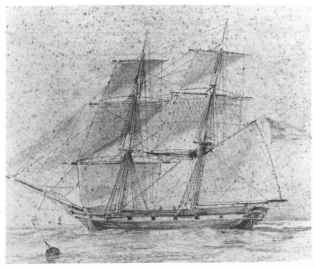

115

116

117

118

116. Unidentified American brig. 245 tons. 7½ x 9¾ in. (19 x 24.7 cm.). M5222

117. Unidentified British brig. 8¼ x 9¾ in. (21 x 24.7 cm.). M5223

118. Unidentified xebec. Signed, l.r., "marseille FR." 6 x 7⅜ in. (15.3 x 18.7 cm.). M5224

LITHOGRAPHS

119. DELAWARE [United States warship]. Uncolored lithograph. Image size: 15⅝ x 23 in. (39.6 x 58.4 cm.). Signed, l.l., "Fᶜ Roux," and dated, l.r., "1834." Imprint: l.l., "Peint par Antoine Roux, (perè [sic]) à Marseille," center, "Imp. Lith. de Lemercier," and l.r., "Lith par Frédéric Roux à Paris." Inscription below image: "The United States Ship DELAWARE, near the Western Islands August 25ᵗʰ 1833 on her, passage to France with His Excellency EDWARD LIVINGSTON. Envoy Extraordinary and Minister Plenipotentiary from the United States to the Court of Sᵗ Cloud Drawn and dedicated to his Commander and Mess Mater [sic] by theer [sic] Obedient Servant F. W. Mogres [followed by facsimile signatures of the ship's officers]." Purchase, 1943. M5168

120. DELAWARE [United States warship]. Colored lithograph. Another state of the above. Image size: 15½ x 22¾ in. (39.4 x 57.9 cm.). Signed, l.l., "Fᶜ Roux," and dated, l.r., "1834." Imprint: l.l., "Peint par Antoine Roux (père) à Marseille," center, "Lith. de Lemercier," and l.r., "Lith. par

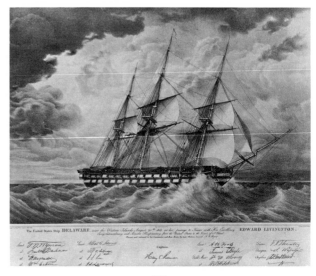

119

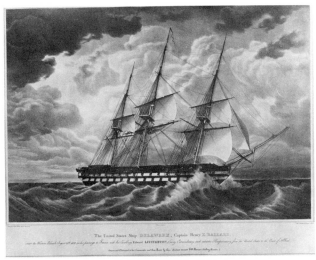

120

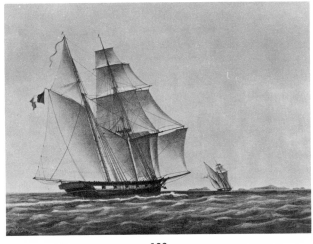

122

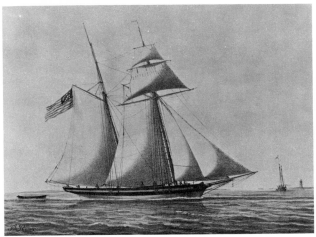

121

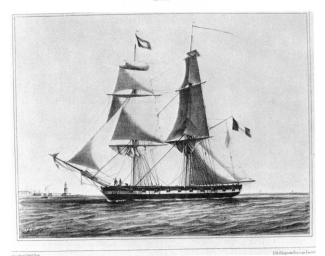

123

Frédéric Roux à Paris." Inscription below image: "The United States Ship DELAWARE, Captain Henry E. BALLARD, near the Western Islands August 25ᵗʰ 1833 on her passage to France with his Excellency Edward LIVINGSTON, Envoy Extraordinary and minister Plenipotentiary, from the United States to the Court of Sᵗ Cloud. Drawn and Dedicated to his Commander and Mess. Master [*sic*] by their obedient servant F.W. Moores (Sailing Master.)." Gift, Stephen Wheatland, 1953. M7980

121. American Topsail Schooner. "Balaou." Colored lithograph. Signed, l.l., "Fᶜ Roux." Circa 1840. Image size: 6¼ x 8¾ in. (15.9 x 22.2 cm.). Imprint: l.l., "Peint at Lith. par Fᶜ Roux," center, "Chez Cihaut frères, Boulevart des Italiens, Nᵒ 5," l.r., "Lith. d'Auguste Bry, Rue Favart, 8." Plate number 8 (upper right-hand corner). Gift, Stephen Wheatland, 1972. M15322

122. French Hermaphrodite Brig of War. "Brick Goëlette." Colored lithograph. Signed, l.l., "F Roux." Circa 1840. Image size: 6¼ x 8¾ in. (15.9 x 22.2 cm.). Imprint: l.l., "Peint et Lith. par F. Roux," center, "Chez Cihaut frères, Boulevart des Italiens 5." l.r., "Lith d'Auguste Bry, rue Favart, 8." Plate number 18 (upper right-hand corner). Gift, Stephen Wheatland, 1972. M15323

123. French Brig of War. "Brick de Guerre." Colored lithograph. Signed, l.l., "Fᶜ Roux." Circa 1840. Image size: 6¼ x 8½ in. (15.9 x 21.6 cm.). Imprint: l.l., "Peint et Lith par Fréderic Roux," center, "Chez Cihaut, frères, Boulevart des Italiens, 5," l.r., "Lith. d'Auguste Bry, rue Favart, 8." Plate number 19 (upper right-hand corner). Gift, Stephen Wheatland, 1972. M15321

FRANÇOIS GEOFFROI ROUX (1811–1882)

THE youngest of the three Roux sons, François was born at Marseille on October 21, 1811. Like his brothers, Louis Brès wrote in 1883, he developed under the paternal eye.

"He also evinced remarkable aptitudes," he went on, "which brought him, as they had Frédéric, the encouragement of Carle and Horace Vernet. But

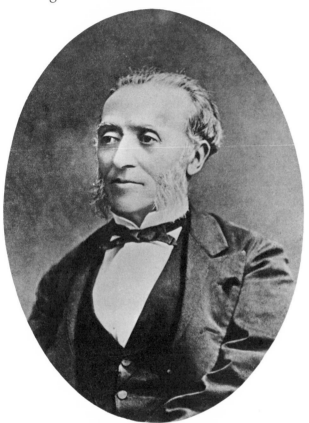

124. François Geoffroi Roux. Peabody Museum photograph collection.

he did not leave for that reason the shop in the quay Saint-Jean where he succeeded his father. There, while selling compasses and charts, he gave himself up with passion to his art. In it he acquired with time a remarkable aptitude.

"Less artist perhaps than his father, less mercurial than his brother Frédéric, he attained as practitioner, an incomparable degree of skill. For him there were no frames too large nor themes too ambitious. Methodical and patient, he seemed to delight in those pictures which demanded persistent

labor and a surety of hand capable of coping with all difficulties. His methods as a water-colorist, approached those of the modern English School. He pushed to the very limit the handling of the brush without impairing the freshness of the coloring, which is one of the essential characteristics of water-color painting, without losing anything of the vigor of execution which large surfaces demand. Also, his compositions, while abounding in details, preserved an excellent appearance. From the point of view of truth and precision they offer an exceptional interest."

François's early style had all the characteristics of his upbringing—the regimented waves and all the rest of it. Little by little, however, as he became surer of himself, as he relaxed and learned to trust in his brush, his ship pictures gradually took on that bright, breezy quality so distinct from the work of his brother Antoine, so much looser than most of brother Frédéric's more highly trained endeavors, and far more natural than the studied labors of his father. The true professional in any field has the ability to make his work seem so triflingly easy that anyone could do the same, yet those who try need little time to discover the fallacies of their innocence. Only work, and devotion to it, makes perfect, or as perfect as may be.

It has already been suggested how much the largely self-taught disciplines of Antoine, the father, contributed to the development of the sons' talents. By copying his work, they all learned the rudiments of their trade. To say that François ultimately came to surpass the father's work is in one sense unfair, because each must be judged not only upon his individual merits but upon the tastes and dictates of his own times.

Sometime about midway in his career, François crossed a thin line between above-average ability and superiority. His compositions became brilliant (except, perhaps, when grinding out a ship picture for some impatient Yankee or Scandinavian shipmaster who was to be in port but a few days). Suddenly, his handling of the water he painted matured, although maybe not so suddenly when a

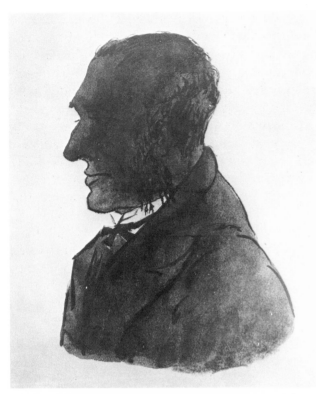

125. Wash sketch of François Geoffroi Roux, by an unidentified artist, in the Peabody Museum collection (M3145).

François showing the development of the French sailing navy, two of miscellaneous and foreign sailing warships, five watercolors of naval side-wheelers, three pictures of screw-propelled naval vessels, nine paintings of ironclads, twenty-eight of commercial sailing vessels, and five of merchant steamers. For his source material, Roux drew heavily upon the watercolors and sketchbooks of his father as well as upon his own experience and personal observation afloat and ashore.

"All these drawings are of a perfect exactitude and finish," Admiral Pâris wrote, "to such an extent in fact, that when they have been photographed one would suppose that the photograph had been taken from nature direct. Each epoch has its peculiarities well defined; the least details show themselves without injuring the whole by their dryness. The modeling especially is remarkable; one sees it from the lines of the ships' boats, which in spite of their smallness would serve a boat-builder in making his models, quite as well as in the drawings of the large vessels. The rigging is absolutely correct and has the finish as well as the lightness which water-colors admit of, when manipulated by an un-

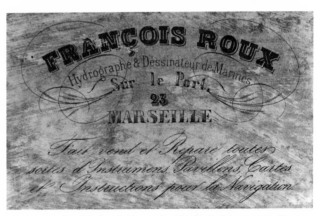

126. Trade label of François Geoffroi Roux, sometimes found attached to the back of his paintings. Peabody Museum collection.

corpus of his work is closely examined. From the artificial, rhythmic treatment, the seas become wet, frothy, hissing with flecks of foam; in short, believable. His use of light and shadow upon sails and sea was better than photographic; there could never be any doubt that his rigging was being plucked by the wind.

There must have been much more to the career and maturation of François Roux than we shall ever know. The highlight of it, no doubt, was a nearly twenty-year labor of love—a tremendous series of watercolors given to the Louvre, illustrating the development of naval and merchant vessels since the last decade of the eighteenth century.

The exact number of these paintings is open to question. Some found their way to the Louvre; others did not. At present, the Musée de la Marine in Paris, where the majority reside, claims seventy-one, but in the 1885 publication by Admiral Pâris, *La Marine Française de 1792 à nos Jours*, even more were reproduced.

It was a noble series, painted between the late 1860's and 1882, the year of the artist's death. Admiral Pâris illustrates twenty-seven pictures by

erring hand. This collection so complete and assuredly unique will transmit to posterity the physiognomy of the ships which it contains better than many pictures however sensational but inexact."

His combined accomplishments won for him, together with the title of "peintre de la marine" the Palmes d'Officier d'Académie (des Beaux Arts) and the Croix of the Légion d'Honneur.

Louis Brès described his appearance shortly before the artist's death. "To see him correctly clad in black, the red ribbon (his decoration) in his buttonhole, his face framed in a long grey mutton-chop whiskers, one would have taken him for a Naval Officer . . . I found him a man of charming manners and a sincere artist."

Edouard Gaubert had a similar impression: "After the death of Antoine Roux [Jr., in 1872] his son Tonin [François Antoine] continued the hydrographic business of the house and it was not until then that I became acquainted with his uncle François who did not at all resemble his brother. He was much thinner and wore side whiskers and he looked like a perfect example of the naval officer of his time. His studio was up one flight and above the shop. It had windows overlooking the harbor, then filled with innumerable sailing vessels whose varying aspects in conjunction with the loading and unloading of merchandise made a never-to-be-forgotten picture. François' studio was decorated with the finest works of art that the Rouxs possessed."

After relinquishing his hydrographic business to his nephew Tonin about 1860, he lived alternately at Marseille and at Paris. "He seemed," according to Brès, "in these latter days to wish to settle permanently in his birthplace." It was during this period when his greatest works were achieved. When he died at Marseille, on September 30, 1882, the Roux dynasty of marine painters came to an end.

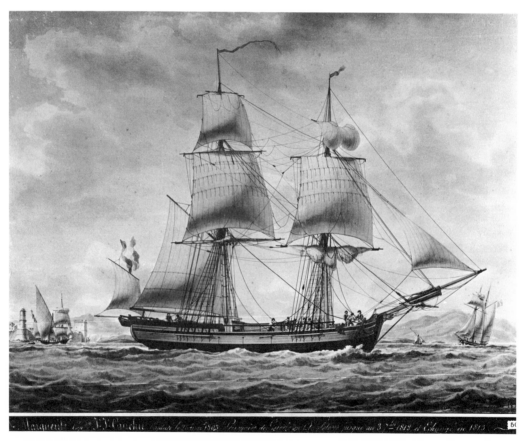

128

62

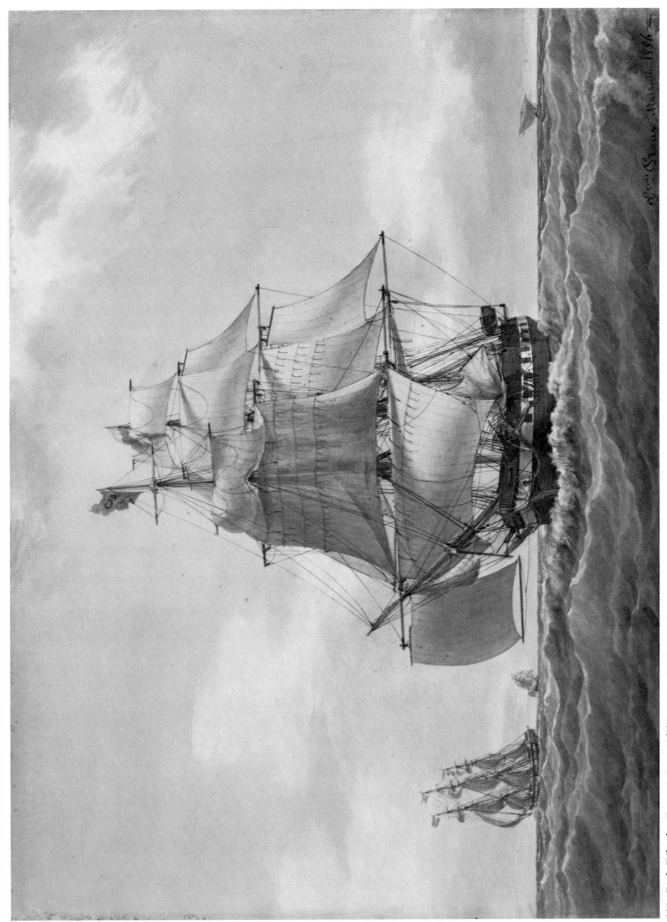

133. Bark *Zélie*, by François Roux, 1856

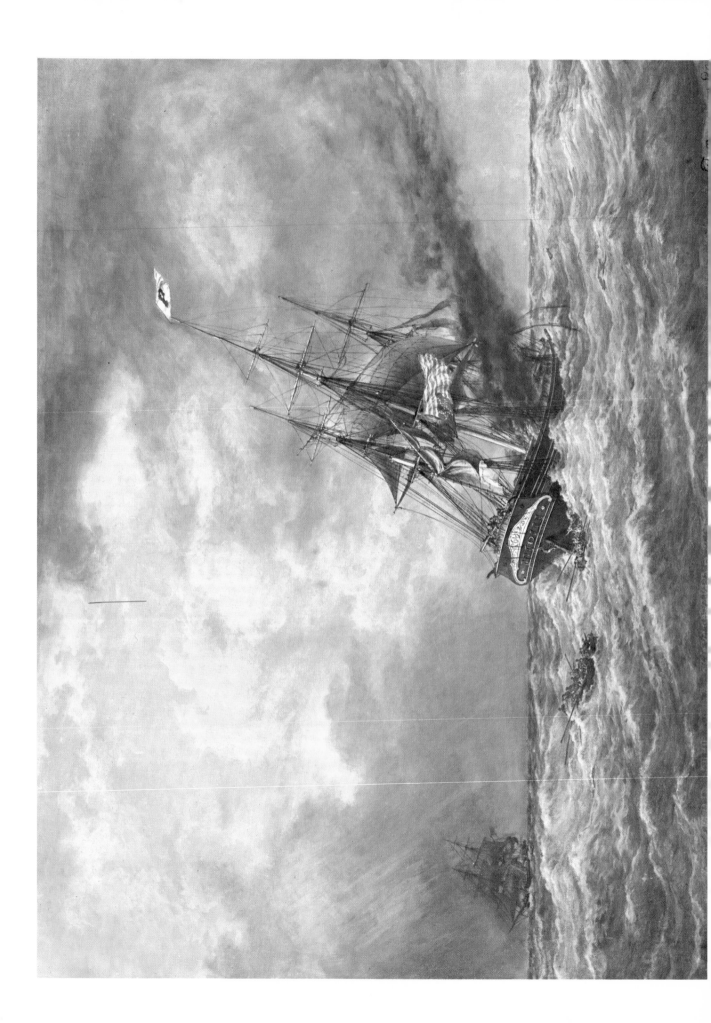

129

127. OLINDA. "Olinda of Salem" [American snow]. Watercolor. 17¼ x 23¼ in. (43.8 x 59 cm.). Signed, l.r., "f^cois Roux à Marseille 1827." Gift, Elizabeth Wheatland, 1894. M200

See color plate facing page 55.

Olinda was built at Salem, Massachusetts, by Elijah Briggs, in 1825. She measured 178 tons, 88' 2" length, 21' 2" extreme breadth, and 10' 7" depth of hold. Owned by Salem merchants Gideon Tucker, Samuel Tucker, and Daniel H. Mansfield, her captain at the time was Richard Wheatland. The snow made numerous voyages from Salem to Europe and South America. In 1847 she was sold to Boston owners.

128. STE. MARGUERITE. "S^te Marguerite, Cap^ne J^n J^s Cauchie Capturé le 28 mai 1803 Prisonnier de Guerre en Angleterre jusque au 3 7^bre 1812, et Echangé en 1813" [French brig]. Watercolor. 17 x 22 in. (43.2 x 55.9 cm.). Signed, l.r., "F^cois Roux à Marseille en mars 1839." Purchase, 1938. M5471

In translation, the caption reads: "Ste. Marguerite, Captain Jn Js Cauchie, captured 28 May 1803, prisoner-of-war in England until 3 September 1812, and exchanged in 1813."

129. RAPIDE. "Rapide, Cap^ne L. Luquet Armateur M^r M^or Fabry Fils 1845" [French bark]. Watercolor. 17¾ x 22½ in. (45.1 x 57.2 cm.). Signed, l.r., "F^cois Roux a Marseille en 7^bre 1845." François Roux's trade card on reverse. Gift, Leonard E. Opdycke, 1977. M17074

The vessel is shown leaving Marseille.

130

130. TROIS AMIS. "Trois Amis, Cap^ne J^ph Mistral Armateur M^rs Boze Père & Fils, 1845" [French snow]. Watercolor. 17 x 22 in. (43.2 x 55.9 cm.). Signed, l.r., "F^çois Roux à Marseille en Juillet 1846." Framer's label on reverse: "A. Chandron 126, Rue d'Aubagne, 126.—Marseille." Purchase, 1931.
M3758

131. MONTAUDEVERT. "Montaudevert Cap^ne V^r Lepetit Armateur M^r Lafargue Fils" [French bark]. Watercolor. 17½ x 22 in. (44.5 x 55.9 cm.). Signed, l.r., "F^çois Roux à Marseille avril 1853." François Roux's trade card on reverse. Gift, Mrs. Michael Gavin, 1955.
M8761

Montaudevert was built at Nantes in 1845 and measured 273 tons. She was owned at this time in Marseille by Gillibert.

132. PARNASSE. "Parnasse" [French bark]. Watercolor. 16¼ x 22 in. (41.3 x 55.9 cm.). Signed, l.r., "F^çois Roux novembre 1856." Gift, from the Richard Wheatland Collection, 1976.
M16524

Also ship-rigged at one time, this bark was built at Bordeaux in 1841 and measured 325 tons. She was owned at Marseille by Roux and Bernabo.

133. ZÉLIE. "Zélie" [French bark]. Watercolor. 17¾ x 22½ in. (45 x 57 cm.). Signed, l.r., "F^çois Roux, Marseille 1856." Gift, from the Richard Wheatland Collection, 1977.
M17128
See color plate facing page 62.

Zélie, 241 tons, was built at La Ciotat, France, in 1829. She was owned at this time in Marseille by Roux and Bernabo. Her captain was J. Gautier.

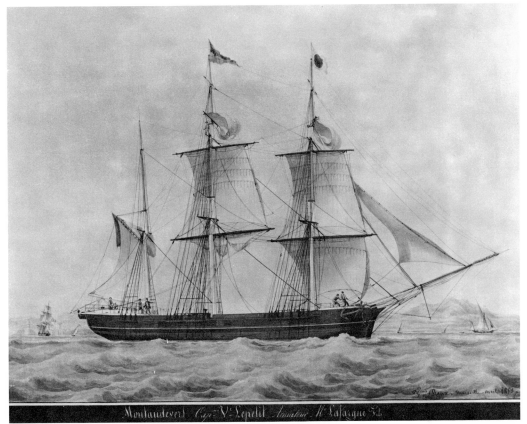

Montandevers Cap.ᵉ V. Lepetit Armateur M. Lafargue Fils

131

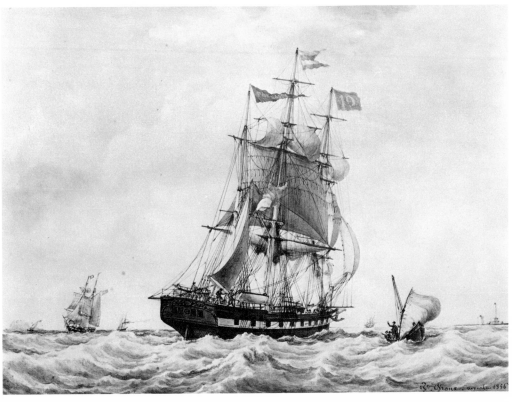

132

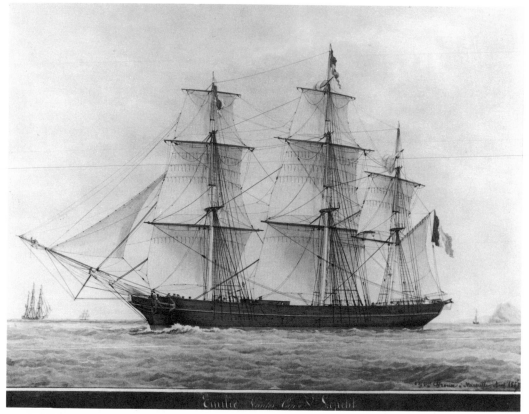

134

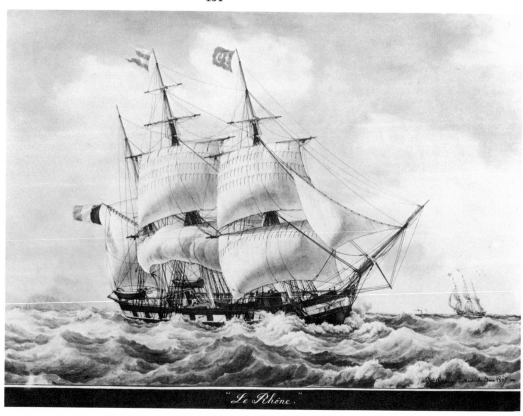

135

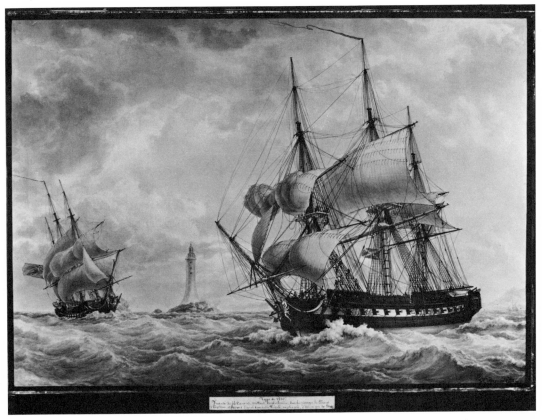

137

134. EMILIE. "Emilie, Nantes, Cap^ne V^r Lepetit" [French ship]. Watercolor. 17¼ x 22 in. (43.8 x 55.9 cm.). Signed, l.r., "F^çois Roux à Marseille, Aout 1857." Gift, Mrs. Michael Gavin, 1955.
M8760

Emilie was built at Lorient in 1855 and hailed from Nantes. A vessel of 390 tons, her master was T. Satre.

135. LE RHÔNE. "Le Rhône" [French bark]. Watercolor. 18 x 23¼ in. (45.7 x 59 cm.). Signed, l.r., "F^çois Roux Marseille, Juin 1857." Gift, from the Richard Wheatland Collection, 1976. M16523

Le Rhône, of 277 tons, was built at Marseille in 1835, whence she also hailed. Her captain was J. Cauvi; her owners, Roux and Bernabo.

136. POLAND [American ship]. Watercolor. 20¾ x 27½ in. (52.7 x 69.8 cm.). Signed, l.r., "F^çois Roux Marseille 1860." Gift, from the Richard Wheatland Collection, 1964. M12293
See color plate facing page 63.

Poland was built at New York by Bergh in 1832. She measured 546 tons, 131′ length, 30′ extreme breadth, and 15′ depth of hold. A packet of the Havre Whitlock Line from 1833 to 1840, she was struck by lightning in May, 1840. Her cargo of cotton was set afire, and all attempts to smother the blaze proved fruitless. The boats were filled and passengers were towed astern. After two days, the *Clifton* (shown coming up out of a squall in this painting) appeared and rescued all on board, but *Poland* was totally destroyed. *Clifton*, of Boston, Captain I. B. Ingersoll, was bound from Liverpool to New York with 240 steerage passengers on board.

137. British Warships off Eddystone Light, Plymouth, England. "Type de 1810 Frégate de 44 Canons, mettant Vent-Arrière, Sur les parages de Phare d'Edystone, et faisant Signal à un autre Frégate au plus prés, d'arriver par ses Eaux." Watercolor. 21 x 29 in. (53.3 x 73.6 cm.). Signed, l.r., "F^çois Roux 1882." Gift, from the Richard Wheatland Collection, 1972. M15311

"44-gun Frigate, typical of 1810 running before the wind in the waters off Eddystone Lighthouse, and making signals to another frigate, close hauled, to fall into her wake." A copy of a painting by Antoine Roux, Senior, this painting was done as part of a series executed by François for the Musée de la Marine in Paris, but remained in his possession until his death. It must have been one of his last.

139

140

SKETCHBOOKS

[NOTE: None of the following are signed, but based on stylistic evidence or dates given for various sketches they have been attributed to François Roux.]

138. Sketchbook. Twelve pages of pencil, wash, and ink drawings of figures; charcoal and pencil drawings of country and rococo subjects. 10⅛ x 14¼ in. (25.7 x 36.1 cm.). Gift, Richard Wheatland, 1926. M12422

Not illustrated.

This sketchbook was included in another (M11832, described below), thus accounting for the attribution, but if this was one by François it was one of his childhood exercise books. The drawings are naïve and seemingly the work of a beginner.

139. Sketchbook. Unsigned. 10¼ x 16¼ in. (26.1 x 41.2 cm.). Gift, Richard Wheatland, 1926. M11832

This sketchbook contains 6 watercolors, 2 pencil, and 2 wash drawings. Identified subjects are: the brig *Pénélope* of Marseille, p. 2; the brig *Trois Monts Rouges,* dated 1842, p. 3; the Turkish corvette *L'Africaine,* built at Marseille, p. 17; *L'Husseinia,* p. 18; and the Turkish corvette *Ulalie,* built at Marseille, pp. 19 and 20.

140. Sketchbook. Unsigned. 10¼ x 16⅜ in. (26.1 x 41.6 cm.). Gift, Richard Wheatland, 1926. M11832

This sketchbook contains 23 pencil drawings and 3 wash sketches. Identified subjects are: the steamer *Rhône,* p. 5; flags of the "Paquebots Postes faisant les Voyages du Levant," p. 6; the snow *L'Olivier,* opposite p. 10; the ship *Terence* of Marseille, pp. 11, 12, 13; the steamer *Sphinx,* loose sheet; the snow *La Prospérité,* p. 15; the Greek corvette *Amalia,* dated 1843, p. 16; the steamer *La Napoléon,* dated 1843, p. 18; the steamer *Gladiator,* dated 1868, p. 21. The latest sketch is dated September, 1871.

141. Sketchbook. 9¼ x 12 in. (23.5 x 30.5 cm.). Purchase, 1972. M15278

Originally attributed to Frédéric Roux, this sketchbook is now believed to be the work of François, largely on grounds of stylistic evidence. It appears to contain work copied, or adapted, from studies by Antoine Roux, Senior, thus accounting for dates too early to be the original efforts of either son. It is unsigned, but is embossed on the cover "F✳R✳✳." Identified subjects are: H.M. brig *Wasp,* p. 1; the French fifty-gun warship *Le Robert* (sketched at Toulon), p. 2; the snow *Le Turc-Napadamis,* p. 3; the United States brig of war *Spark* (sketched at Endoume), opposite p. 4; the Greek brig *Leonidas,* opposite p. 5; the French hermaphrodite brig *Vestale,* p. 5; the forward half of the *Mulgrave* warship, opposite p. 7; H.M.S. *Swiftsure* (sketched at Endoume), p. 7; the eighty-gun ship *Le Septre* (sketched at Marseille), p. 8; H.M.S. *Romulus,* opposite p. 10; and the brig *L'Étoile* of Marseille, p. 21. The sketchbook contains 22 watercolors and 6 pencil sketches.

the Wasp — Guêpe

141

SELECT BIBLIOGRAPHY

Brès, Louis, *Une Dynastie de Peintres de Marine, Antoine Roux et ses Fils* (Marseille: Librairie Marseillaise, 1883). The work was translated by Alfred Johnson for *Ships and Shipping* (which see, below).

Brewington, M. V. and Dorothy, *Marine Paintings and Drawings in the Peabody Museum* (Salem, Massachusetts: Peabody Museum of Salem, 1968).

[Brewington, M. V.], "Antoine Roux Sketch Books," *The American Neptune* Pictorial Supplement Number 2 (Salem, Massachusetts: *The American Neptune*, 1960).

Johnson, Alfred, trans., "A Dynasty of Marine Painters, Antoine Roux and his Sons," *Ships and Shipping, A Collection of Pictures Including Many American Vessels Painted by Antoine Roux and his Sons* (Salem, Massachusetts: Marine Research Society, 1925).

Meissonnier, Jean, *Sailing Ships of the Romantic Era, A 19th Century Album of Watercolors by Antoine Roux*, and the French language edition *Voiliers de l'Époque Romantique, Peints par Antoine Roux* (Lausanne: Édita Lausanne, 1968). Also the German language edition *Segelschiffe im Zeitalter der Romantik, Aquarelle und Zeichnungen des 19. Jahrhunderts von Antoine Roux* (Bielefeld-Berlin: Delius, Klasing & Co., 1968).

———, "Ship Painters of the Mediterranean," The Magazine *Antiques*, March, 1963.

———, "Une dynastie de Peintres de Marines," *La Revue Française*, November, 1961.

———, "A dynasty of marine painters: the Roux family of Marseilles," The Magazine *Antiques*, November, 1964.

Pâris, L'Amiral E., *L'Oeuvre de François Roux, représentant les Portraits de Navires de la Marine Française de 1792 à nos Jours* (Paris: A. Liébert, 1885).

Vichot, Jacques, *L'Album de l'Amiral Willaumez* (Paris: Musée de la Marine, n.d.).

[], "Antoine Roux et ses Fils, les fameux Portraitistes de navires du XIX^e siécle," *Nouvelles "Mixte,"* November, 1958.

EXHIBITION CATALOGUES

A Catalogue of a Loan Exhibition of Ship Portraits by the Roux Family of Marseilles (Searsport, Maine: The Penobscot Marine Museum, 1939).

Antoine Roux et ses Fils (Marseille: Musée Cantini, 1955).

INDEX

INDEX

72